LOST
BLACKPOOL

CHRIS BOTTOMLEY & ALLAN W. WOOD

AMBERLEY

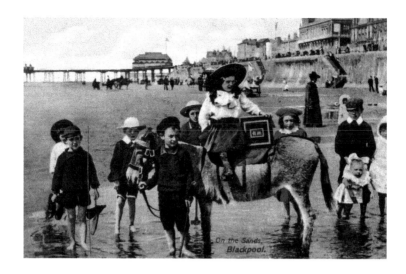

We would like to give special thanks to Ted Lightbown, Tony Sharkey, Ian McLoughlin, Blackpool Evening Gazette, Emma Harris, Blackpool Local History Library and Peter Crossley for their kind assistance.

First published 2019

Amberley Publishing
The Hill, Stroud
Gloucestershire, GL5 4EP

www.amberley-books.com

British Library Cataloguing in Publication Data.

A catalogue record for this book is available from the British Library.

ISBN 978 1 4456 8533 5 (print)
ISBN 978 1 4456 8534 2 (ebook)

Typesetting by Aura Technology and Software Services, India.
Printed in the UK.

Contents

Introduction

Sometimes change is for the better, sometimes it is not. It is often a matter of perspective. Perhaps some of us remember the simpler times of the past through rose-tinted glasses. From its meteoric growth in the nineteenth and twentieth centuries, to the heady post-war days of the 1950s and '60s, to the decline that started in the early 1970s, Blackpool has changed and is still changing. The development and reinvestment in recent years is promising for the future.

Along with the wider social changes that occur, changes in our physical surroundings are inevitable. Recent examples of lost buildings and change include the building and extension of the Houndshill Shopping Centre in place of the dozens of small individual shops around what was the Victoria Street, Sefton Street and Adelaide Street area; the building of the Talbot Road Gateway; the tramline extension along Talbot Road; the transformation of the Golden Mile from numerous individual stalls and shows to large amusement arcades; the new promenade works; and the absence of deckchairs on the beach.

Probably the most well-known buildings/attractions that have been lost from Blackpool's landscape are the Big Wheel (1929) and the Palace (1962), and later Lewis's (1993), Derby Baths (1990), Yates's Wine Lodge in Talbot Square (2009) and the Syndicate (2015). These subjects (and others) have been covered several times in other books and are given the prominence they deserve in section 1 of this book. Although not demolished at the date this book was completed, due to their imminent departure from the landscape we have also included the Wilko (Wilkinsons) building on Talbot Road and the now-redundant police station on Bonny Street.

Lost Blackpool contains six sections. Section 1 includes what are probably the most well-known buildings and attractions that have gone. These are generally in a chronological order. The other sections are laid out in an approximate north to south order. Section 2 looks at the north part of Blackpool (north of Talbot Road, traditionally the boundary of North Shore). Section 3 includes some of the changes to the town and includes a section on its lost streets and a section of black and white photos from late 1963 of the shops and premises of the town centre, taken as part of the early planning for the Houndshill Shopping Centre. Section 4 looks at central Blackpool, mainly the promenade – from Talbot Road to the Foxhall Hotel. Section 5 looks at the south part of Blackpool – from Manchester Square to the airport. Finally, section 6 includes subjects from around the outskirts of the town.

There are many more 'lost' buildings (schools, churches, theatres, cinemas, pubs, working men's clubs and nightclubs) that space in the book did not allow. Hopefully we have captured most of the ones people remember.

Well-known Places

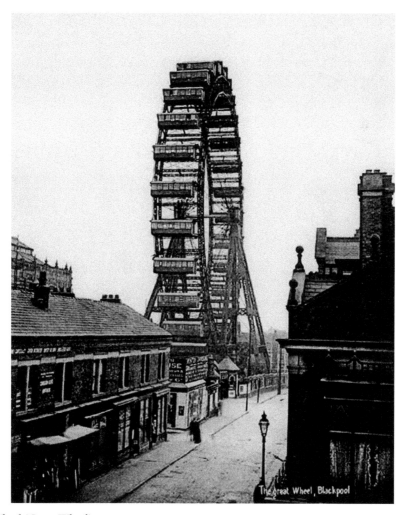

Big Wheel (Great Wheel)

The Big Wheel was built by The Blackpool Gigantic Wheel Company and opened on 22 August 1896, on the corner of Coronation Street and Adelaide Street. It was 220 feet in height and had thirty carriages, each capable of holding thirty passengers. The Tower Company took over the Winter Gardens in 1928 and the last ride was on 28 October 1928. The Big Wheel was dismantled in 1929 and the Olympia opened on the site in 1930.

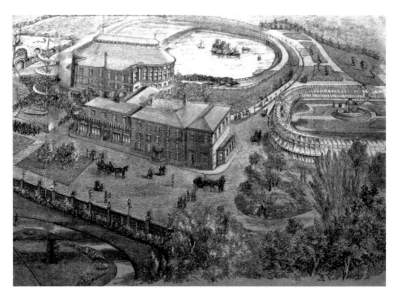

Raikes Hall Gardens

Raikes Hall Park, Gardens and Aquarium Company purchased the *c.* 1765 Raikes Hall in 1870. The hall had previously been used as a convent girls' school by the Sisters of the Holy Child Jesus who moved to Layton Hill Convent (now St Mary's Catholic Academy). Raikes Hall Gardens opened on Whit Monday 1872. Blackpool FC played most of their matches there from 1888/89 to 1897/98. It became the Royal Palace Gardens in 1887, but closed in 1898. The land was sold for building in 1901. (Courtesy of David Slattery-Christy)

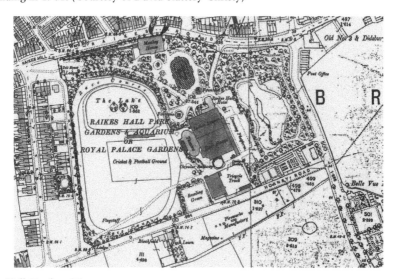

Raikes Hall Gardens Map

The map shows the extent of what was Raikes Hall Park, Gardens and Aquarium (or the Royal Palace Gardens) in around 1890. The main entrance, with its impressive gates, was at the Church Street corner of Raikes Parade. The gardens were bounded by Church Street to the north, Hornby Road to the south, Whitegate Drive to the east and Raikes Parade to the west. It developed to include extensive gardens, a conservatory, roller-skating rink, the Indian Lounge, a theatre, ballroom, dancing platform, monkey house and boating lake. (Courtesy of Blackpool Central Library)

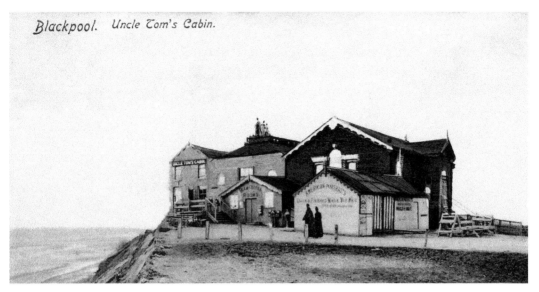

Blackpool. Uncle Tom's Cabin.

Uncle Tom's Cabin

Uncle Tom's Cabin was on the edge of the cliffs approximately opposite the end of Shaftesbury Avenue. It began as a refreshment stall in the early 1850s, then was replaced by a hut and named Uncle Tom's. The hut was taken over by Robert Taylor and William Parker in 1858. The building was extended with concerts and dancing being introduced. It closed on Friday 4 October 1907 due to erosion of the cliffs and was demolished in January 1908.

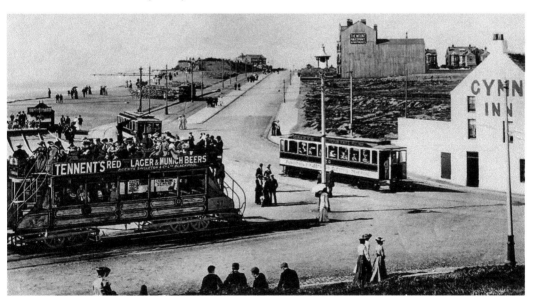

Gynn Inn, Gynn Square – Looking North

In this *c.* 1905 postcard view the Mount Hotel stands alone on Queen's Promenade. The Gynn Inn was originally a farmhouse, built *c.* 1740, and was later one of Blackpool's earliest lodging houses. It became a public house in the 1850s and became known as the Gynn Inn *c.* 1861. The pub was demolished in August 1921 to make way for the new road layout and tramway extension. Its site is now the Gynn roundabout.

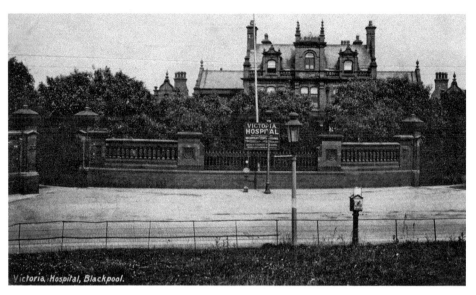

Victoria Hospital, Whitegate Drive

Blackpool's first hospital opened on 25 August 1894 on Whitegate Lane (now Drive), with four wards containing twelve beds and three cots. It became the Victoria Hospital in 1897 when two new wings were added and subsequently moved to the new hospital site at Whinney Heys in September 1936. The Whitegate Drive site became the Municipal Health Centre and was later redeveloped as the Whitegate Health Centre, which opened in 2009.

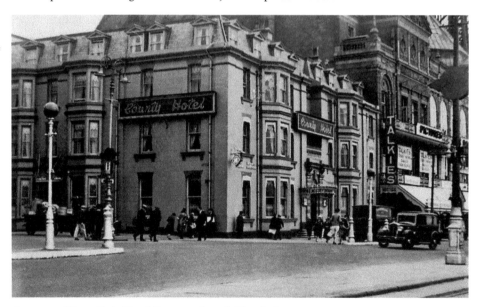

County and Lane Ends Hotel, Promenade and Church Street

The promenade end of what is now Church Street was known as Lane Ends in the eighteenth century, and Lane Ends Hotel was situated there from the mid-1700s. It was demolished in 1864, being rebuilt and reopened in 1865 as the County and Lane Ends Hotel. The hotel had another storey added in 1927. It was demolished in 1961 – at the same time as the adjoining Palace Theatre. The site is now occupied by the (seasonal) Vegas Diner. (Courtesy of Peter Dumville)

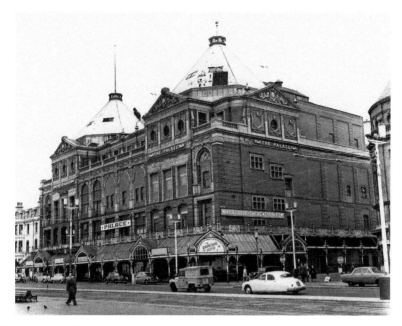

The Palace, Promenade

Originally built as the Alhambra in 1897–99 on the site of the Prince of Wales Theatre and Baths. It contained the Palace Variety Theatre, a ballroom, circus, roof garden and large central entrance hall, restaurant and café. It closed on 22 November 1902 and was purchased by the Blackpool Tower Company, who renamed it The Palace. It reopened on 4 July 1904 and was marketed as 'The Peoples Popular Palace of Pleasure'. It closed in 1961 to make way for Lewis's department store.

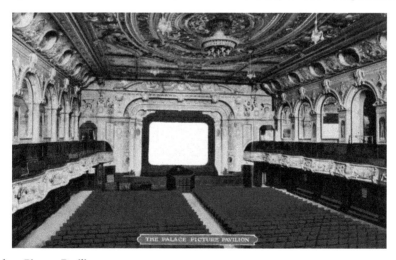

The Palace Picture Pavilion

It is thought films were being shown in the Alhambra in 1902. After its purchase by the Tower Company, the ballroom was converted into a Panopticum (exhibition room). Its circus became the ballroom, and films were screened. Vernon's Bioscope was installed in 1909 and it was called the Palace Pictures until 1911, when it reverted to a ballroom. From 1911, a new cinema with 1,972 seats was created where the circus had been, named the Palace Picture Pavilion. It closed in September 1961.

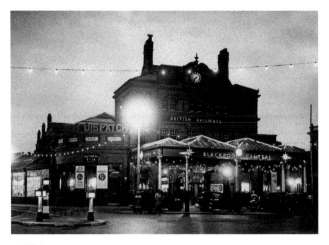

Central Station at Night

Hounds Hill station opened on 6 April 1863 and was renamed Central station in 1878. In 1901, it had fourteen platforms and was one of the busiest railway stations in the country. The station closed on 2 November 1964 as part of the Beeching recommendations and was, in part, used as a bingo hall until 1973, after which time the station (excluding the toilet block) was demolished. Coral Island amusement arcade now stands on the site of the former ticket hall.

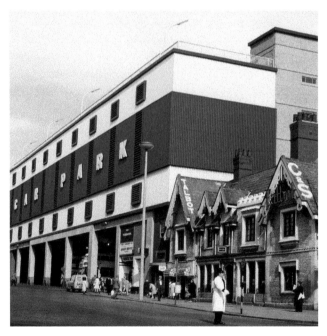

Talbot Road Bus Station and the Talbot Hotel

Talbot Road bus station and car park was completed in 1939 by Atherton Bros (Blackpool) Ltd. The ground floor was designed to accommodate double-decker buses and the car park above for 750 cars. As part of the Talbot Gateway project, the ground floor bus station was converted to commercial units. The Talbot Hotel was built by Thomas Clifton in 1845. From 1873, it hosted an annual bowling tournament, known as the 'Derby' of the bowling world. The Talbot was demolished in 1968 and Prudential House built on the site.

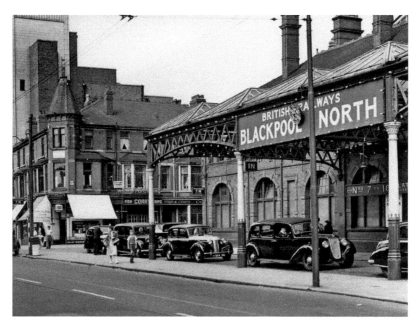

North Station

Blackpool's first railway station opened as Talbot Road station on 29 April 1846 and was renamed North station in 1872. It then fronted onto what was to become Dickson Road. The original terminus building was classical in style and was replaced in 1898 by a red terracotta and brick building with a clock tower and large cast-iron and glass canopy over the entrance.

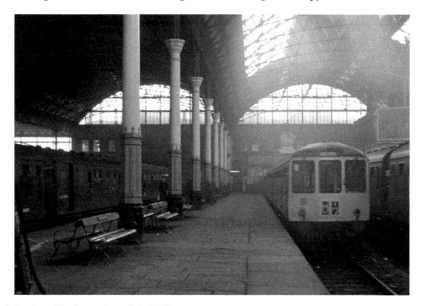

North Station, Platforms 3 and 4, 1973

Platforms 3 and 4 of North station are seen here in January 1973, shortly before the station was demolished and moved further back to the site of the former 1930s excursion hall near High Street. Various supermarkets have since occupied the Dickson Road/Talbot Road site, including Fine Fare and Food Giant. It is now occupied by Wilko (Wilkinsons). (Courtesy of Ian McLoughlin)

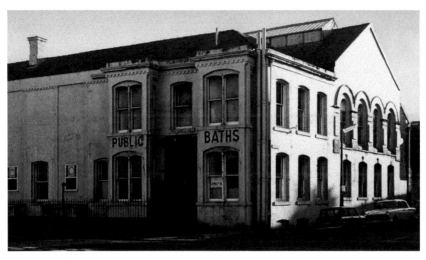

Cocker Street Baths, Cocker Square

Cocker Street Baths were originally built as sea water baths in 1870. They were acquired and modified by Jonathan Read and reopened in July 1873. They were purchased by the council on 19 April 1909 and used mainly for school swimming lessons. The baths had a surrounding upper gallery and a large skylight. Lucy Morton trained there before winning the 1924 Summer Olympic Games Women's 200 metre breaststroke. The baths were demolished in March 1974 and the site is now a car park. (Courtesy of Alan Stott and Melanie Silburn)

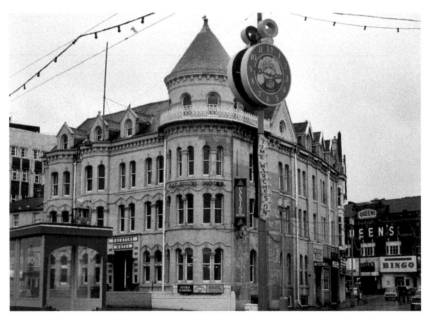

Palatine (Family and Commercial) Hotel, Promenade at Hounds Hill

The Palatine Hotel opened in 1879. It was in an excellent position opposite Central station and at the north end of the Golden Mile. It was demolished in 1973–74 and the site was redeveloped, with the Palace nightclub above, which later became The Sands Venue. The Sands Venue Hotel Resort, Blackpool's first five-star hotel is now being built on the site and it is planned to incorporate the new Blackpool Museum. (Courtesy of Ian McLoughlin)

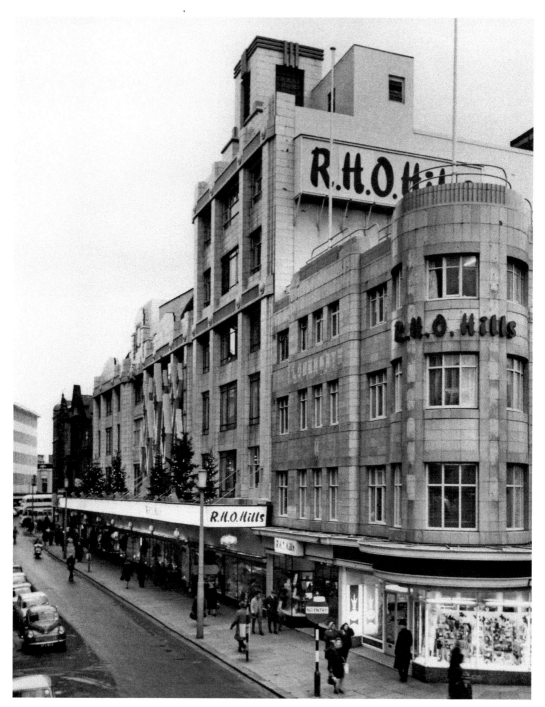

RHO Hills

RHO Hills on Bank Hey Street was, for many years, Blackpool's premier department store. It suffered major fires in January 1932 and May 1967. The store was taken over by House of Fraser in 1975 and became Binns, until its closure in 1987. The building now houses Primark and HMV and is part of the Houndshill Shopping Centre. (Courtesy of Ian McLoughlin)

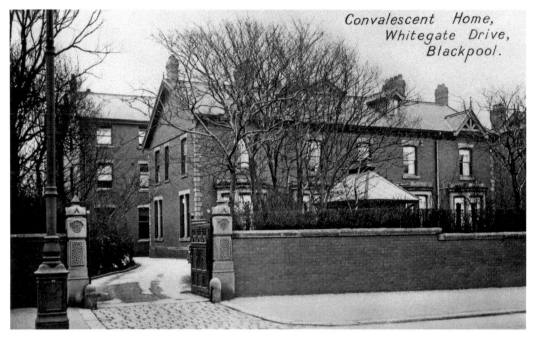

Convalescent Home, Whitegate Drive, Blackpool.

Glenroyd

Glenroyd, at No. 164 Whitegate Drive, opened on 14 April 1906 as the Co-operative Convalescent Home. It was requisitioned at the outbreak of the Second World War as an emergency maternity home and remained a maternity hospital until 1 October 1974. It closed following the completion of the new maternity wing at Victoria Hospital, and was demolished *c.* 1975. It is now the site of the Glenroyd Medical Practice and Glenroyd Care Home.

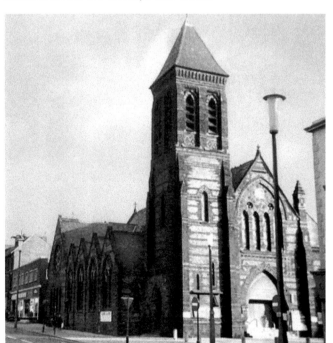

Christ Church, Queen Street

Christ Church, Church of England, was founded as a 'tin' mission in 1861 and stood at the corner of Abingdon Street and Queen Street. The Gothic-style church, with its multicoloured brickwork and pebbled panels, was opened in 1866. Despite a campaign to save it, the church was demolished in 1982. Its site became a car park, until the Queen Street Job Centre was built in 1993, which has since closed. (Courtesy of Genuki)

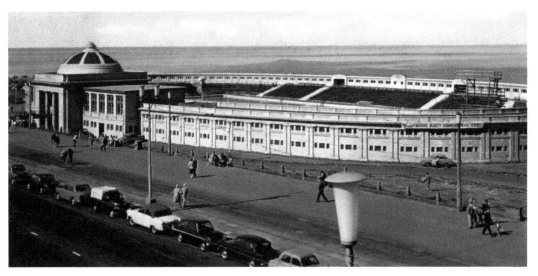

South Shore Open Air Baths, South Promenade

The open-air baths, adjacent to South Pier, opened on 9 June 1923 in a classical 'Colosseum' style to a design by the borough architect J. C. Robinson. The baths were said to be the largest open-air baths in the world and hosted the Miss Blackpool and Miss United Kingdom beauty contests for many years, as well as It's a Knockout. Unpredictable weather and changing public requirements led to its closure in the early 1980s and demolition in 1983. The Sandcastle Water Park opened on the site in 1986.

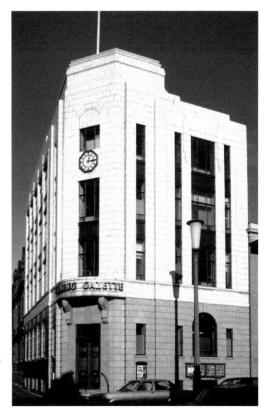

Evening Gazette, Victoria Street

The *Evening Gazette*'s offices on Victoria Street were designed by local architect Halstead Best and opened in 1934. In 1987 the offices moved to the former Telefusion offices on Cherry Tree Road North and later to the Blackpool Business Park off Squires Gate Lane. The Victoria Street site is now occupied by the jewellers F. Hinds. (Courtesy of Ted Lightbown)

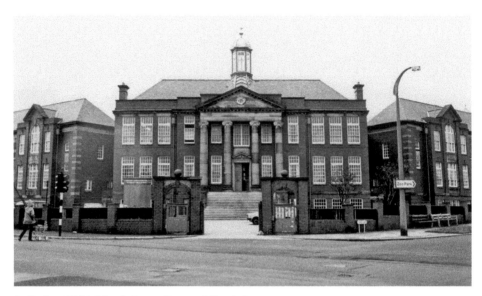

Collegiate Girls' School, Forest Gate and Beech Avenue

The Girls' Secondary School at the corner of Forest Gate and Beech Avenue was designed by J. C. Robinson and opened in September 1925. It was later known as the Collegiate Girls' School, but was used latterly called Tyldesley before closing in 1985. It was demolished in 1987 and replaced by the Grizedale Court flats. (Courtesy of *Evening Gazette*)

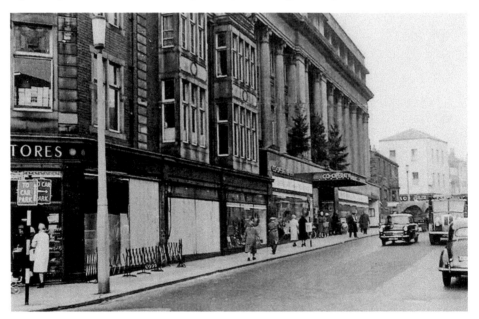

Co-op Emporium, Coronation Street

Famous for its 'dividends', the Co-op Emporium, with its pillars to the Coronation Street frontage, was built by the Blackpool Co-operative Society in 1938. The 'superstore' had everything under one roof, including the 800-seat Jubilee Theatre on the top floor. The Emporium's site was cleared in 1988 and was used as a car park for many years. In 2008, the Debenhams anchor store of the refurbished and extended Houndshill Shopping Centre opened on the site.

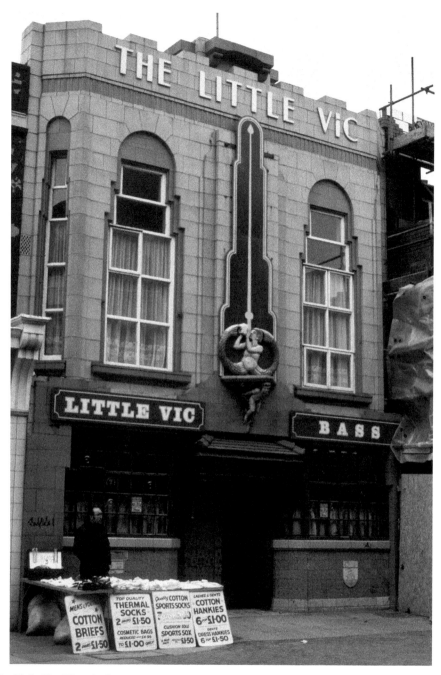

The Little Vic, Victoria Street

Built for C&S Brewery in 1933 on the site of the old (1880s) Victoria Vaults (Victoria Inn). Designed by John C. Derham, its façade was a blend of Spanish-Colonial and art deco styles. Andrew Mazzei designed the interior in a Spanish theme. The bell tower at the front of the building was removed in the 1970s and the building was demolished in 1989 to make way for new shops. The site is now occupied by UIKO, a men's designer clothes shop. (Courtesy of Ian McLoughlin)

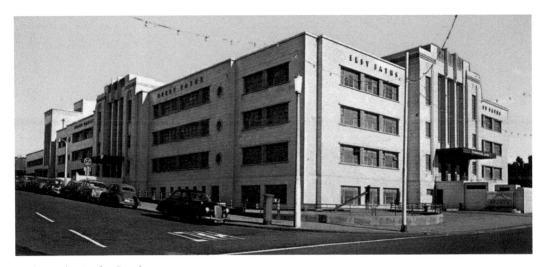

Derby Baths, Warley Road

Derby Baths, with its distinctive yellow-faience cladding, first opened as a seawater baths in July 1939. Despite the addition of the separate sauna building in 1965 and the Splashland tubular water slides in 1987, by the 1980s it was failing to compete with attractions such as the Sandcastle Water Park. The baths closed in 1987 and was demolished in 1990. While there have been plans for a new hotel on the site, it remains undeveloped.

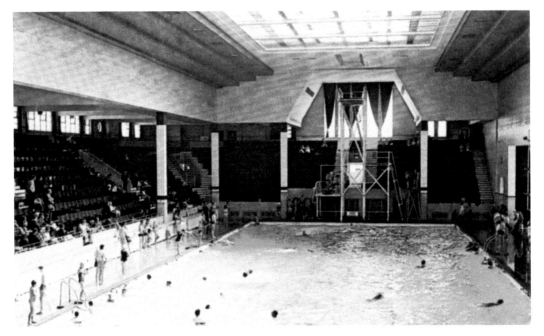

Derby Baths Pool

In 1949, Derby Baths hosted The Water Follies starring Johnny Weissmuller, who was famous for playing Tarzan in several 1930s and '40s films. In the 1950s and '60s, Derby Baths were the home of the annual ASA Centralised Championships. The baths hosted UK and international televised swimming events and diving competitions. It had an Olympic-sized pool, 10-metre-high diving board at the east end, a learner pool in the basement and a sun terrace on the south-facing part of the roof.

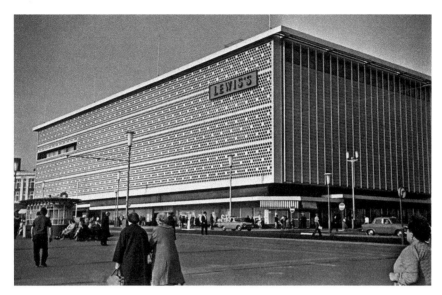

Lewis's, Promenade

Lewis's department store was built on the promenade sites of the Palace Theatre and County Hotel. It opened on 2 April 1964 and instantly rivalled RHO Hills as Blackpool's premier department store. The bright and modern building had escalators to all five floors. Lewis's closed on 9 January 1993 and the building was remodelled, with the top two floors being removed. The site now houses a Poundland store, but has a number of empty units on Bank Hey Street. (Courtesy of David Ayres)

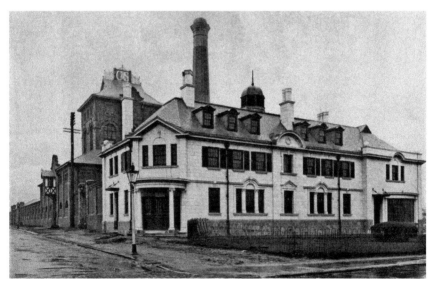

Catterall & Swarbrick Brewery (C&S), Talbot Road

Established at Queen's Brewery, Poulton-le-Fylde in 1880, Catterall & Swarbrick Brewery Limited was formed in 1894. In 1927, C&S built the Queen's Brewery on Talbot Road. It was famous for its 'XL' bottled ale. In 1961, C&S became part of the Charrington organisation before merging with Bass in 1967 to become Bass Charrington, later Bass plc. Brewing ceased in 1974. The brewery was demolished in 2000 and is now the site of residential homes, with roads being named Coopers Way, Catterall Close and Swarbrick Close.

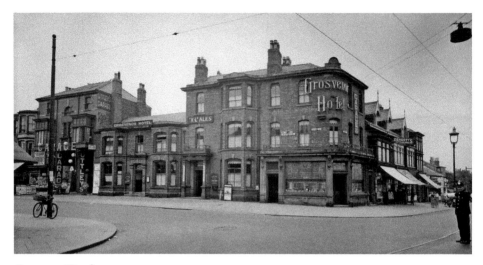

Grosvenor Hotel

In 1873/4, George Ormerod built the Raikes Hall Hotel on the Cookson Street corner with Church Street. It changed its name *c.* 1895 to the Grosvenor Hotel, when it was owned by C&S. Irish comedian Frank Carson owned the pub in the late 1970s. For a while it was named the Cow Bar and then Hello Dollies. The pub later fell into disrepair and was closed *c.* 2003. The Grosvenor, along with adjacent properties, was demolished in 2007 and is a temporary car park. (Courtesy of Ian McLoughlin)

Devonshire Road Hospital

The Blackpool Sanatorium opened on 7 July 1891. It was built, in green fields on New Road (now Talbot Road), to isolate infectious diseases outside of the town's built-up area. It was later named Devonshire Road Infectious Diseases Hospital. The extensive hospital buildings were demolished in 2007 and the land is now a large open brownfield space, earmarked for housing development. (Courtesy of *Evening Gazette*)

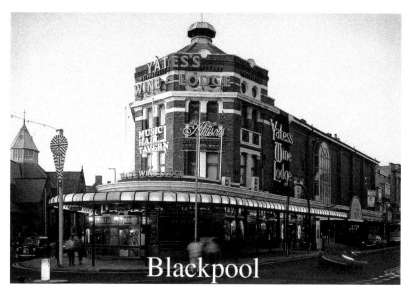

Yates's Wine Lodge, Talbot Square

Yates's was the most well-known (and iconic) licensed premises in Blackpool and opened in July 1896 on the ground floor of what was originally the Theatre Royal (1868) and later (1880) the Blackpool Free Public Library and Reading Rooms. It was famous for its Australian white wine and its draught champagne stall. Yates's was destroyed by fire on 15 February 2009 and subsequently demolished. A new 150-room, six-storey, Premier Inn is being erected on the site.

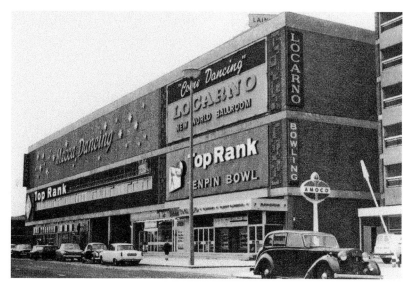

Locarno (Mecca), Central Drive

The Mecca Ballroom, with its revolving stage, opened in 1965 as the Locarno. Upstairs was the Highland Room, one of northern soul's top venues. The DJs in the Highland Room were originally Tony Jebb and Stuart Freeman and during the week Billy the Kid; later DJs were Ian Levine and Colin Curtis. It was renamed Tiffany's in the late 1970s and housed the Commonwealth Sporting Club from 1977 to 1989. It was demolished in 2009. The site is now being developed for residential housing.

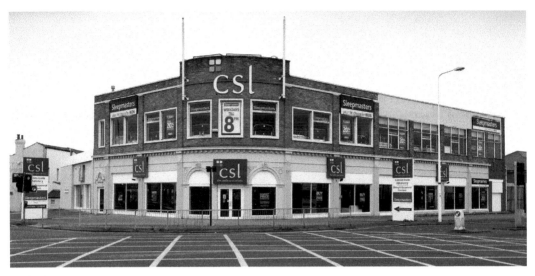

Oxford Corner

Dating from the late 1920s, Thomas Motors (main dealer for Ford) was built as a single-storey car showroom. The first floor was added in the 1950s. In the late 1990s, Thomas Motors left the site and CSL Lounge Suites moved into the old car showrooms (later Sofaworks). The ground-floor façade was in faience tiles with large picture windows. As part of the Aldi development in 2015, the façade was partly retained and repositioned forwards. (Courtesy of Historic England)

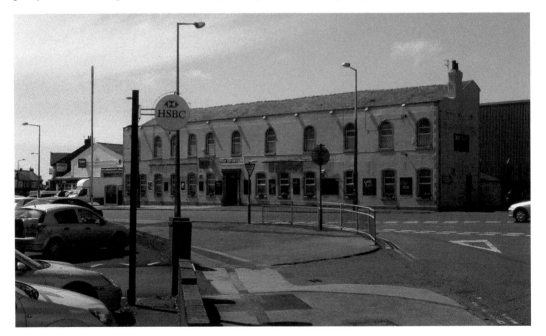

The Oxford Hotel, Waterloo Road

In the mid-1800s the Oxford Hotel was named the Mill Inn due to the adjacent windmill, which dated from *c.* 1775. It became the Oxford Hotel around 1889 and later was owned by C&S. It is seen here in 1963. In 2007 it was renamed Bickerstaffes. It closed in 2009 and was demolished in 2015. The site is now occupied by an Aldi supermarket. (Courtesy of Ted Lightbown)

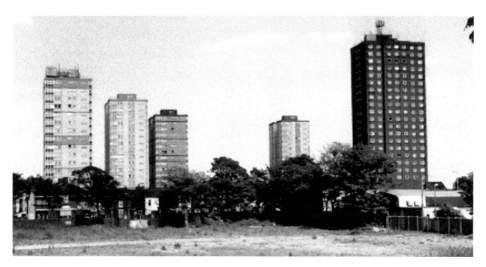

Queenstown, Layton

Now known as Queens Park, the Queenstown area of Blackpool was developed in the late 1870s after New Road (later Talbot Road) was built from North station to Layton. The terraced houses of Wildman Street, St Joseph Road, Thomas Street and Ward Street were demolished in the early 1960s and the sixteen-storey Charles Court, Ashworth Court, Elizabeth Court and Churchill Court were built, with the twenty-two-storey Walter Robinson Court being completed in 1972. The tower blocks were demolished in 2014–2016 and replaced by houses.

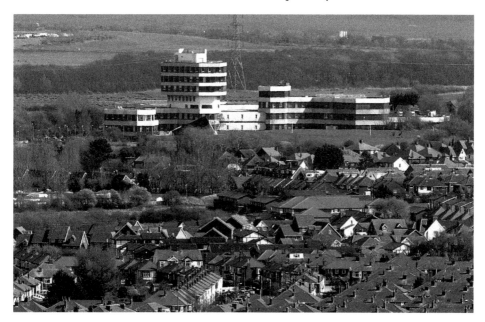

ERNIE Building – National Savings

The Premium Bonds office on Mythop Road, Marton, housing ERNIE (Electronic Random Number Indicator Equipment) was moved to Blackpool in 1977–78. It was an unusually shaped building and many thought the eight-storey tower was an airport control tower. The tower building at the National Savings & Investments site was demolished (blown up) on 26 February 2017 and over 100 houses are being built on the site. (Courtesy of *Evening Gazette*)

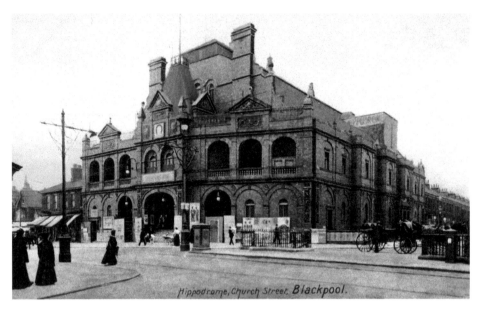

Hippodrome, Church Street, Blackpool.

Hippodrome Theatre

The Empire Theatre opened in 1895 on the corner of Church Street and King Street. It became the Hippodrome Theatre in 1900, when it housed a circus. It later became a cinema and variety theatre and was bought by Associated British Cinemas in 1927. It closed in 1960 and in 1962 was largely demolished for the building of the ABC Theatre.

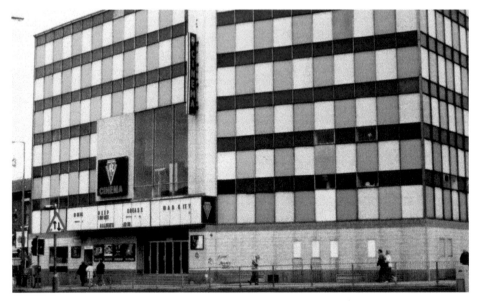

ABC Theatre

The Hippodrome was remodelled and reopened as the ABC Theatre on 31 May 1963 with *Holiday Carnival* starring Cliff Richard & the Shadows. The Beatles performed there twice in the 1960s, as well as Morecambe and Wise (1965), Cilla Black (1966 and 1969) and Les Dawson (1977). The theatre closed in 1981 and was converted to a three-screen Canon Cinema, later the MGM Cinema and finally the ABC Cinema, which closed in 1998.

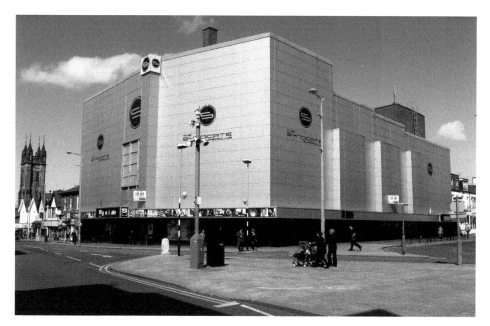

Syndicate Nightclub

The ABC Cinema was converted into the Syndicate nightclub 'super club' at a cost of around £4 million and opened in December 2002. At that time it claimed to be the largest nightclub in the UK. The club closed in 2011 and the building was demolished in 2015. It is now a car park.

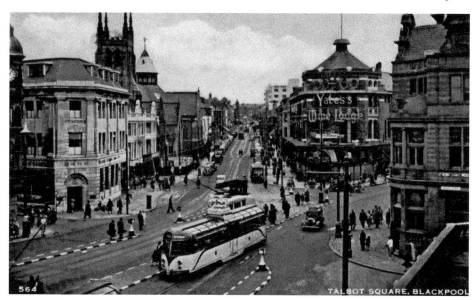

Talbot Square, 1963

Talbot Square was once known as Belle Vue Square and became the focal point of the town with the Town Hall, Clifton Hotel, North Pier and Yate's Wine Lodge. For many years the Town Hall was the centre of the famous Illuminations 'switch on' with celebrities such Ken Dodd, Matt Busby, Red Rum and Terry Wogan doing the honours. The tramway from Talbot Square to Layton closed in 1936, but the route as far as Dickson Road has recently been reconstructed.

Wilko (Wilkinsons), Talbot Road

Fine Fare opened on the Dickson Road site of North station on 22 May 1979. It was rebranded as Gateway in the mid-1980s and sold to Somerfield (Food Giant). The store was later taken over by Wilkinsons who changed its name to Wilko Retail Limited in June 2014. The store is planned to be demolished in 2020 to make way for a new hotel and the terminus of the new tram link along Talbot Road from North Pier to North station.

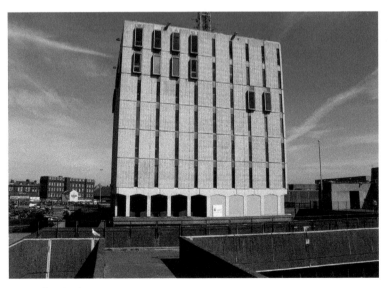

Bonny Street Police Station

Blackpool's first police station was in Bonny Street, and in 1862 the station moved to the site of what is now Abingdon Street Market. A new police station and courts opened on South King Street in 1892, at a cost of £20,500. The police headquarters transferred to Bonny Street in 1971, as seen in the picture, and in July 2018 it moved again to the new headquarters at Marton, adjacent to Tesco. The Bonny Street building is due to be demolished.

North Blackpool

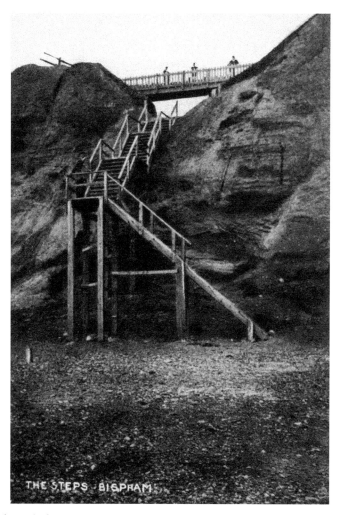

Steps to Beach at Bispham

This *c.* 1907 photograph shows the wooden steps down the 100-foot-high cliffs near Red Bank Road. In 1917, the northern boundary of the borough of Blackpool (then near King Edward Avenue) was extended to take in Bispham with Norbreck and the council constructed a sea wall to protect the cliffs, which was completed in 1921. It was reported in 1920 the rate of erosion of the cliffs in the previous thirty years had been 2 yards per annum.

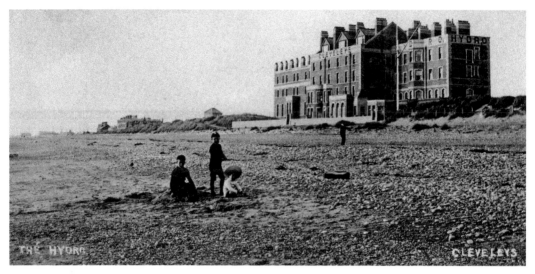

Cleveleys Hydro

Cleveleys Hydro (seen here in 1906) is included in this book as it was within the borough of Blackpool, on its northern boundary, between Anchorsholme Lane and Kingsway. It had been developed as a hotel in the late nineteenth century from Eryngo Lodge (built in 1850) and was occupied by dispersed civil servants during the Second World War. It was demolished between 1956 and 1959. The site of the hotel and golf course is now occupied by the residential developments of Alconbury Place, Buckden Close and Chatteris Place.

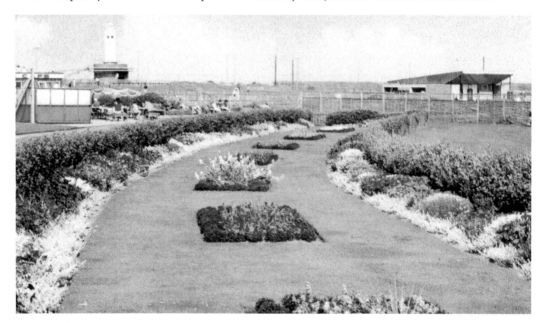

Anchorsholme Park

Anchorsholme Park has been used since 2015 by construction companies building the new sea-defence works, new storm water tank and pumping station in the park, together with a long sea outfall. It is planned to reinstate and reopen the park in 2019. In the background to this 1978 postcard view is the Kent Tower, the ventilation tower for the old Anchorsholme Pumping Station built in 1939 to a design by J. C. Robinson. It was taken down in 1982.

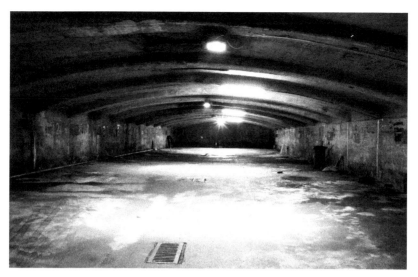

Little Bispham Underground Car Park

The car park was located behind Little Bispham tram station, close to the sea wall. It was built in 1935 when Princes Way was constructed and had space for ninety cars. It was used by Vickers Armstrong (aircraft manufacturers) during the Second World War as a secret store. From 1971 the Fylde Boat Angling Club used the car park as a boat and tractor store. The underground space, which was susceptible to flooding, was filled in recently as part of the Anchorsholme sea-defence works. (Courtesy of Ian McLoughlin)

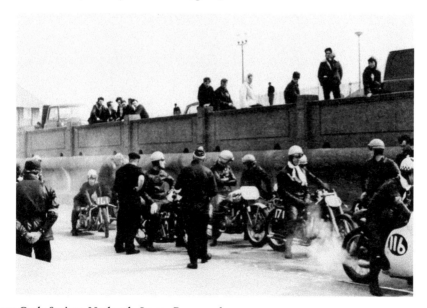

Motor Cycle Sprints, Norbreck, Lower Promenade

The Motor Cycle Sprints attracted around 100 entrants each year and were watched by thousands of spectators. In 2001, the Auto Cycle Union (the motorcycle racing governing body) declared the track unsafe, bringing an end to an event that had run every summer for forty years. For the past seventeen years the event has been organised by the Fleetwood and District Motorcycle Club. (Courtesy of Dick Craven)

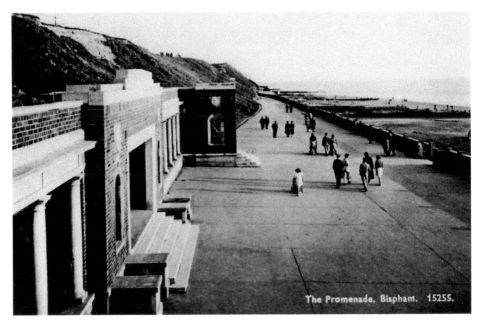

The Promenade, Bispham. 15255.

Sun Parlour, Lower Promenade, Bispham

The attractive sun parlour with its colonnades and roof bandstand on Lower Walk, near Madison Avenue, was built in the 1930s. It was designed in a modernist style by J. C. Robinson, who also designed the tram stations at Bispham and Little Bispham. Part of it was used at one time as a store by the council's sea defence workers. The building was demolished c2000.

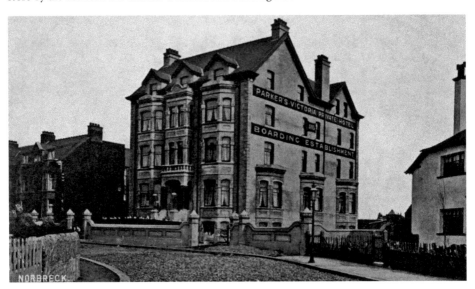

NORBRECK

The Mariners, No. 8 Norbreck Road

Originally this building, which became the Mariners public house, was Parker's Victoria Private Hotel, situated opposite the Norbreck Hydro Hotel. It was used for many years as accommodation for the staff of the Norbreck Hydro. Before it became the Mariners Bar it was called Maggie Mays. The building was badly damaged by fire in August 2007 and demolished in 2008. The site remains undeveloped.

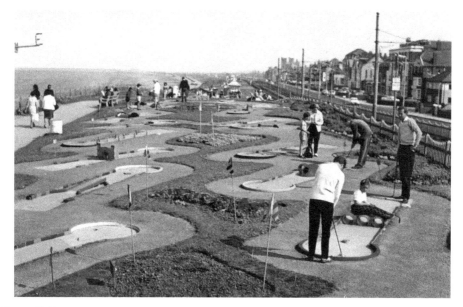

Crazy Golf

In simpler times, putting and crazy golf were popular forms of entertainment, with courses shoe-horned into small spaces along the promenade, such as adjacent to Bispham tram station (shown here in 1972), Anchorsholme Park, near Norbreck tram station, Gynn Gardens, Pembroke Gardens, in the sunken gardens to the north of the Metropole, the Pleasure Beach and at Starr Gate.

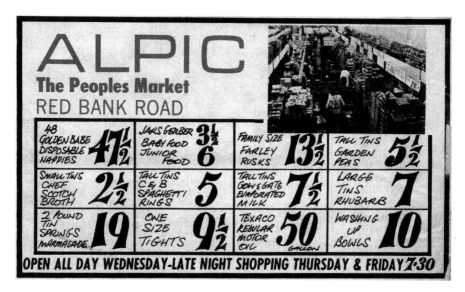

Alpic, Red Bank Road

The electricity works and tramway depot on Red Bank Road was built in 1898. It had room to house thirty-six trams on six tracks. The depot closed on 27 October 1963 and was used as Alpic Cash & Carry until the mid-1970s when it was demolished to make way for a Sainsbury's supermarket and car park. With its concrete floor and aisles of low-cost goods, Alpic was a no-frills supermarket. (Courtesy of Nick Moore)

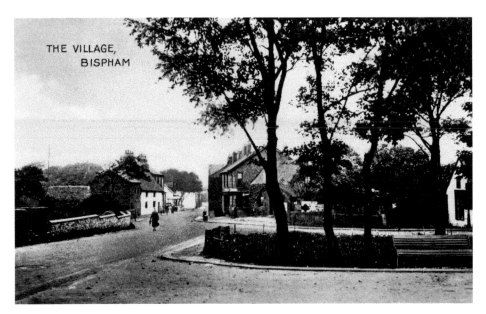

THE VILLAGE, BISPHAM

Bispham Village, c. 1931

Bispham features in the Domesday Book (1086) and was a village in its own right until 1910, when it became the urban district of Bispham with Norbreck. It was amalgamated into Blackpool on 1 April 1919. This c. 1931 postcard view is looking east along Red Bank Road into the village from where Devonshire Road roundabout is now.

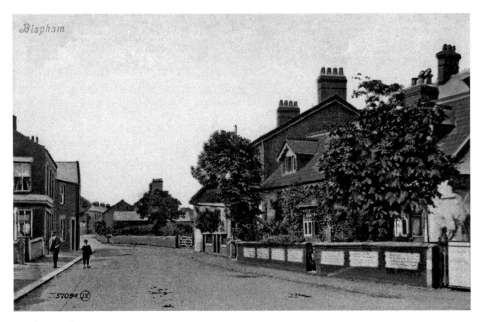

Bispham

Bispham Village, c. 1909

This postcard view of Bispham village, taken c. 1909, looking west along Red Bank Road, shows Ivy Cottage, which originally had a thatched roof. Ivy Cottage's location was partly in the road and car park of the shopping centre, opposite Bispham Market. Bispham village was redeveloped in the 1960s.

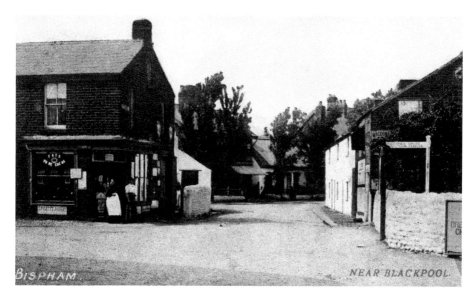

Bispham Village, c. 1906

This postcard view of Bispham village is looking north from near the corner of Blackpool Road and what was the Albion public house (later the Old England, now the Albion again). To the left is the post office on an island, in the centre of Bispham village, at the corner of All Hallows Road and Red Bank Road. The cottages and post office were demolished in 1937.

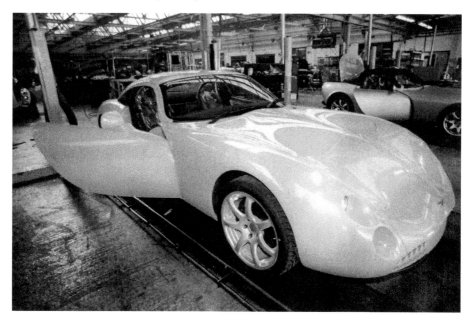

TVR, Bristol Avenue

Trevcar Motors was started by Trevor Wilkinson in 1946 in Beverley Grove, Blackpool. It became TVR Engineering in 1947 when Jack Pickard joined the company. They built their first one-off car in 1949. The factory moved to Hoo Hill, Layton, in the 1960s and to Nutbrown's (kitchenware) factory on Bristol Avenue in late December 1970 until 2006. The factory is now occupied by various tenants. (Courtesy of John Mleczek)

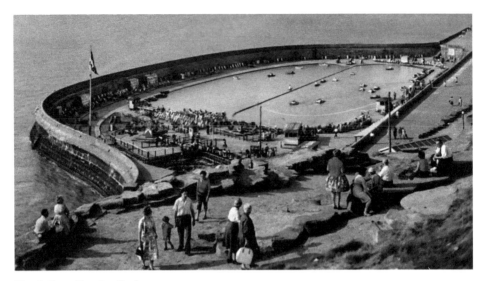

North Shore Boating Pool

The original sea wall to the Boating Pool at North Shore was completed in 1921, albeit the enclosed area was planned to be an open-air baths. The location benefitted from its sheltered environment. Attractions included motorboats, canoes, deckchairs and children's rides. It was successfully run by the Maxwell family for many years until the 1970s. Changing public requirements rendered the attraction obsolete and it is now laid out for use as a go-kart track.

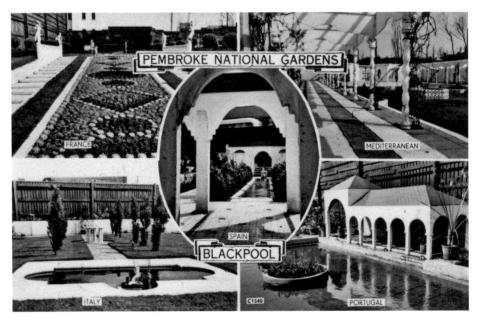

Pembroke Gardens

Pembroke National Gardens were built in the late 1950s on the promenade adjacent to Derby Baths. The land had previously been used as tennis courts and, as this postcard view shows, the gardens had areas depicting countries of the world. It also had a crazy golf course area. After falling into disrepair the Pembroke Hotel was built and opened in 1982. The hotel later became the Stakis Hotel (1986), then the Hilton Hotel in 1999. It is now the Grand Hotel.

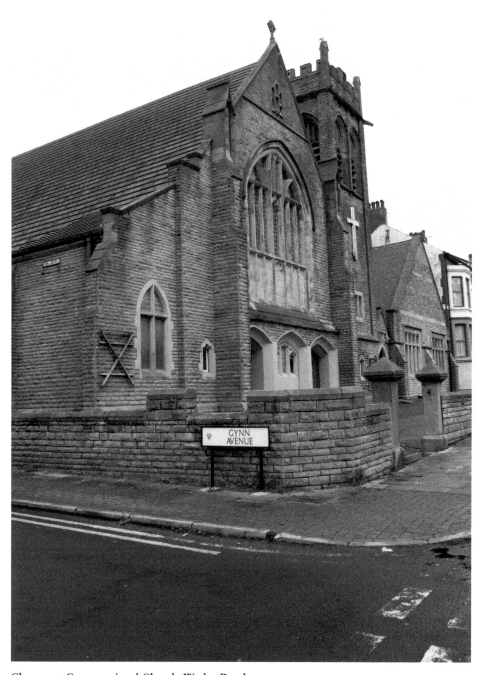

Claremont Congregational Church, Warley Road

Claremont Congregational Church was opened on 30 August 1901, on the corner of Warley Road and Gynn Avenue. In 1972, the church amalgamated with the English Presbyterian church to become the United Reformed Church. It closed in 1994 and later became the Kings Christian Centre. The property was sold at auction in September 2016 for £200,000 with planning consent to erect fifteen two-bedroomed flats and was demolished in late 2016. It remains undeveloped at this date.

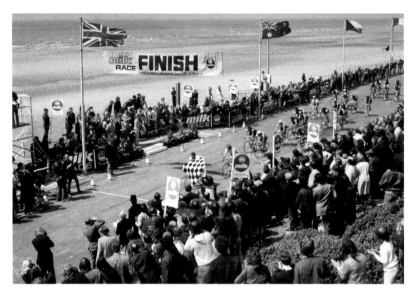

Milk Race, Middle Walk

The Milk Race (1958–93) was a popular annual 'Tour of Britain' cycling competition sponsored by the Milk Marketing Board. The photograph, seen here, was taken by Ian McLoughlin on 9 June 1973 and shows the finish of the Milk Race on Middle Walk. The winner of the race from Penrith was Jo De Boer of the Netherlands. (Courtesy of Ian McLoughlin)

Claremont Secondary Modern School

While Claremont Council School (infants and juniors) on Claremont Road dates from 1907, the senior school was built in 1927. Originally the school for eleven to fourteen year olds was mixed, but it was later divided. The senior school had a practical bias and the boys' school speciality was building science. The boys' school closed in 1969 and moved to Warbreck Boys' School on Warbreck Hill Road. The girls' school closed in 1975 and merged with Arnold High School for Girls on Bispham Road.

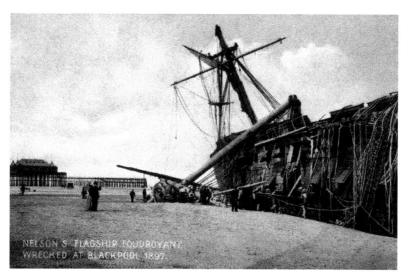

Foudroyant (wrecked 1897)

Foudroyant was Nelson's flagship, which was launched in 1798 and retired from active service in 1812. It was serving as a floating museum when it was wrecked on 16 June 1897 opposite the Metropole Hotel. The crew of twenty-seven were all taken off by the Samuel Fletcher lifeboat. The wreck was sold and parts of it made into souvenirs. Some of the timbers were used for the building of St Paul's Church, North Shore.

Odeon Site, Springfield Road

The block of shops, offices and rooms bounded by Dickson Road, Springfield Road, Lord Street and Queen Street, partially seen in this photograph, was built *c.* 1897. The northern part of the block was demolished in 1938 and replaced by the new Odeon cinema, which opened on 6 May 1939. It could accommodate 3,000 people on its two levels. The cinema closed in 1998 and the building reopened in 2003 as Basil Newby's Funny Girls and Flamingo.

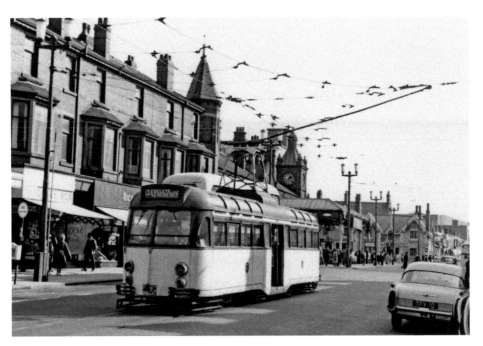

Dickson Road Terminus

The Blackpool and Fleetwood Tramroad opened in July 1898 and ran 8 miles from near Queen Street on Dickson Road via the Gynn to Fleetwood. It was taken over by the council in 1920 and the line between Dickson Road and Gynn Square survived until Sunday 27 October 1963. A Brush car is seen in this photograph.

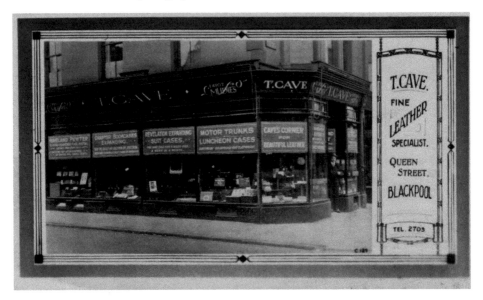

Caves Corner, No. 41 Queen Street

Caves Corner on the south-west corner of Queen Street and Abingdon Street was a well-known, high-class gift store that specialised in leather goods. The pressures of modern trading caught up with it and it closed in 2018. It remains empty.

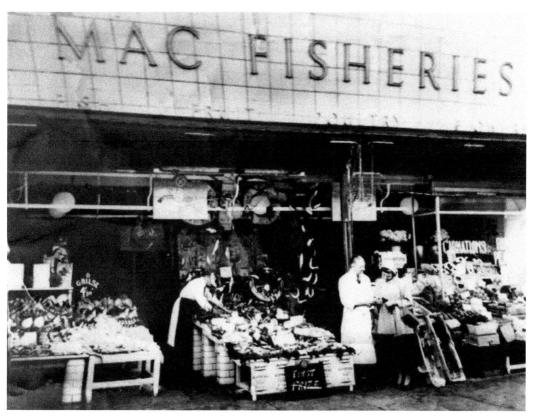

Mac Fisheries, Abingdon Street

Until the late 1970s this shop at Nos 68–70 Abingdon Street was Mac Fisheries, the fishmongers, founded *c.* 1919 by William Lever, 1st Viscount Leverhulme, co-founder of Lever Brothers. Later the shop was used as a tile shop, Jack's Sports Bar (Vibe Bar), Lucy's Two Bar (*c.* 2008) and Timeout (2009). Since 2010 it has been the Galleon Bar, a live music and karaoke bar.

3

Town Centre

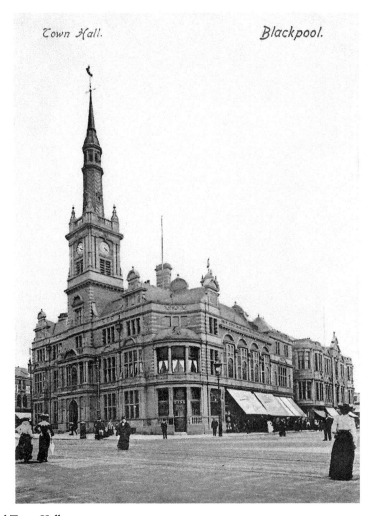

Blackpool Town Hall
Blackpool's first Town Hall stood on the south-west (Market Street) corner of the present Town Hall and was demolished in 1895. The new Town Hall (seen here) was completed in 1900 and had a 180-foot-high spire with an illuminated clock, topped with a ship-shaped weathervane. The spire and weathervane were removed in 1966 on safety grounds. It is a Grade II listed building. (Courtesy of Peter Tyler)

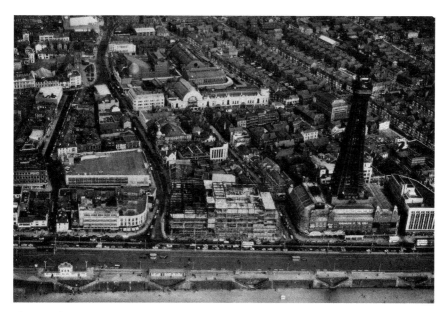

Aerial View of the Town Centre

This 1963 aerial view of the town centre, before it was pedestrianised, shows the part-completed Lewis's building on the promenade and the buildings of the Victoria Street to Adelaide Street area, before the Houndshill Shopping Centre was built. In the centre, on Victoria Street, is the white faience-clad *Gazette* office building and to the right, behind the Tower, is the Co-op Emporium on Coronation Street.

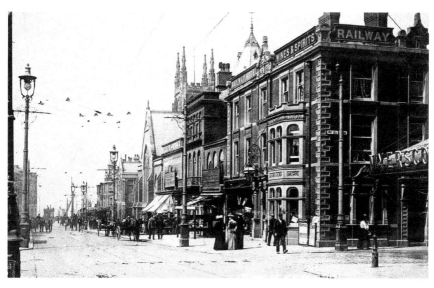

Talbot Road

Talbot Road, looking west from Abingdon Street towards Talbot Square, is seen here in this 1903 postcard view. To the right, on the corner of what was then May Bell Avenue, is the Railway Hotel (now Molloy's), built *c.* 1860. Next to the Railway is Viener's Bazaar (1859). Beyond the Bazaar is Blackpool's first Catholic church, the Church of the Sacred Heart, opened in 1857. The tramline from Talbot Square to Layton (1902–36) has recently been reinstated as far as Dickson Road.

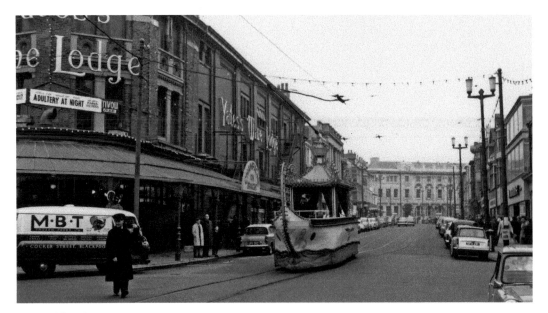

Clifton Street

The Clifton family bought the manor of Layton in 1842 and later a strip of land between Layton and the seafront, where North Pier is now. In the mid-1800s, the residential property of Clifton Street changed to shops and offices, with apartments above. To the left, in this 1960s photograph, is Yates's Wine Lodge, built in 1868. The Gondola tram was an illuminated tram and first appeared in 1925. It was not a public-service tram and carried a small orchestra.

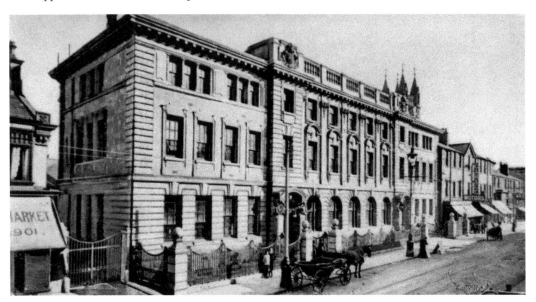

General Post Office

The GPO building on Abingdon Street opened on 8 November 1910 and closed in 2007. It is a Grade II listed building. The eight red K6 telephone boxes on Abingdon Street are also Grade II listed and were designed in 1935 by Giles Gilbert Scott. It is planned to transform the Renaissance-style building into a retail and leisure complex.

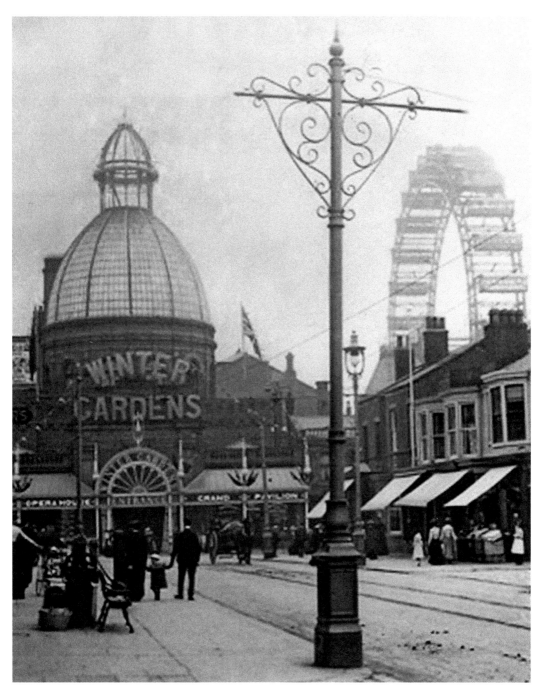

Winter Gardens

The Winter Gardens were built on the 4-acre Bank Hey estate of Dr W. H. Cocker and officially opened on 11 July 1878. The Church Street entrance, with its 120-foot-high circular glass dome, the Grand Pavilion, Vestibule and the elegant Floral Hall, with its curved glass and steel roof, opened in 1878. The 220-foot Great Wheel opened in 1896 and the glass arched Winter Gardens entrance on Coronation Street was completed in 1897.

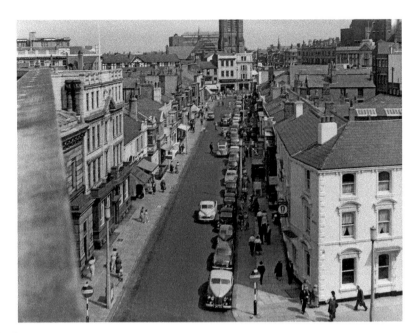

Birley Street

Birley Street is seen here on 24 July 1959 from the roof of the Municipal Buildings before the Crown Hotel, on the right, was rebuilt in 1963. The street was pedestrianised in 1996. In 2009 the 9-metre-high Brilliance arches, designed by Greg McLenahan for light and sound shows, were erected. The street now hosts part of the annual Lightpool festival. (Courtesy of Ted Lightbown)

Corporation Street

Lytham Street became Corporation Street in 1925 in order to remove duplicate street names in the town. The buildings in the centre of this 1950s photograph are thought to be have been used by the Civil Defence Corps. The shops and properties that were previously on the west side of Corporation Street, including the Market Hotel and the St John's Market extension buildings, were demolished in 1939 and the land became a car park until BHS opened in 1957. The Fleece, on Market Street, is to the left. (Courtesy of *Evening Gazette*)

Littlewoods, Church Street

Littlewoods Mail Order Stores Ltd was founded in 1937 and opened its first store on Waterloo Road. The Church Street department store, with its café on the first floor, was on the corner of Corporation Street. It was designed by architect Cecil Molyneux Quilter and built in 1938. Littlewoods moved to Bank Hey Street in November 1995. The fourth floor of the Church Street building was removed *c.* 1997 and the property divided into three retail units. The Chinese Buffet now occupies the upper floors.

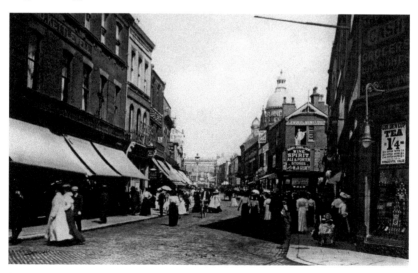

Church Street

From the mid-1700s, Lane Ends (now Church Street) was the main route for visitors to Blackpool and naturally became the centre of the town as it expanded outwards from the seafront. The building to the right in this *c.* 1908 photograph, looking east from Bank Hey Street, was originally The Temple of the Arts photographic studio, which gave its name to Temple Street. The statue of Apollo on the corner of Temple Street was removed in the 1960s and when the advertising board was removed, the carving of *The Three Graces* was rediscovered. (Courtesy of Ted Lightbown)

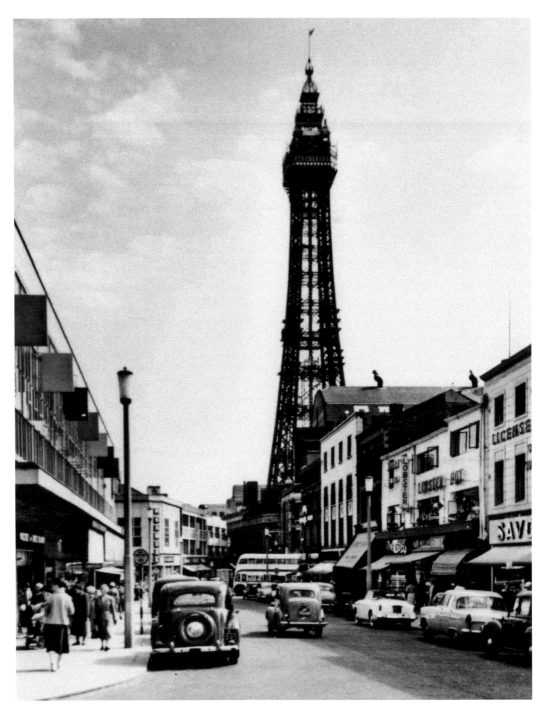

Market Street

Blackpool's first market was St John's Market (1844) on the Market Street site of what is now the Municipal Buildings. This 1960s view of the Tower also shows the newly completed BHS store (1957) to the left, which is now B&M bargain store. To the right is the Lobster Pot restaurant and Savoy Café, where the Revolution Bar and LA Bowl are now.

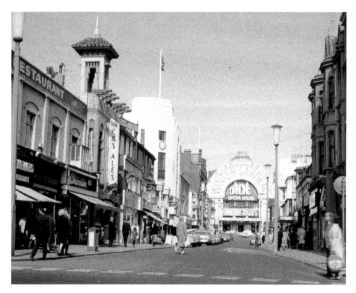

Victoria Street from Bank Hey Street

To the left of this 1970s (pre-pedestrianisation) view looking up Victoria Street from near Bank Hey Street, is Beaverbrooks Jewellers, the Majestic Restaurant, Charisse ladies fashion and the Little Vic pub. Further along is the *Gazette* building on the corner of Temple Street. The Winter Gardens's semicircular sign is not yet partly obscured by the Marks and Spencer development. To the right buildings include the Liberal Club and Stanley Restaurant.

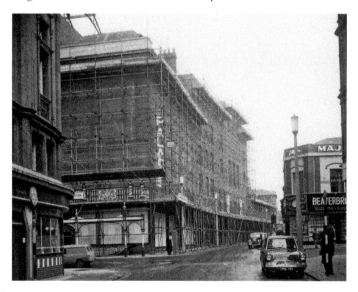

Bank Hey Street

Bank Hey Street was laid out between Lane Ends (Church Street) and Hounds Hill by 1828 and was the route of Blackpool's first sewer. In 1836, Benjamin Heywood built West Hey on what is now the site of the Tower (built 1891–94) between the seafront and Bank Hey Street. The street subsequently became one of Blackpool's main shopping streets, home to RHO Hills and Lewis's department stores. It is seen here with scaffolding around the Palace during its demolition in 1961/62.

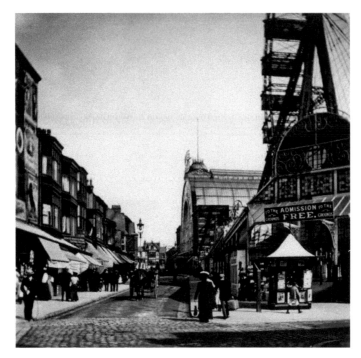

Coronation Street

Coronation Street developed southwards from Church Street in the mid-1800s and was originally Coronation Walk. This *c.* 1912 photograph is of a busy street scene, together with the imposing glass arch entrance to the Winter Gardens opposite Victoria Street. The entrance to the Big Wheel is located on the north-east corner of Adelaide Street.

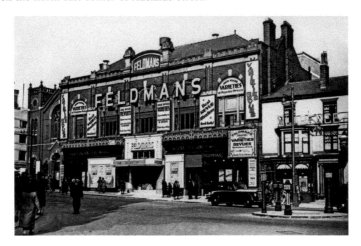

Feldmans Theatre, Hounds Hill

The Borough Theatre occupied this Hounds Hill site from 1877 but closed after two years and became Bannister's Borough Bazaar. Feldmans Theatre was built in 1928 and extensively renovated in 1938. It became the Queen's Theatre in 1952 and opened with a summer revue titled *Singing in the Reign*, starring Josef Locke. The Beatles played there twice in 1963 and Tommy Cooper in 1965. The Queen's closed in 1971 and was demolished in 1973 to make way for a C&A clothing store. It now houses TK Maxx.

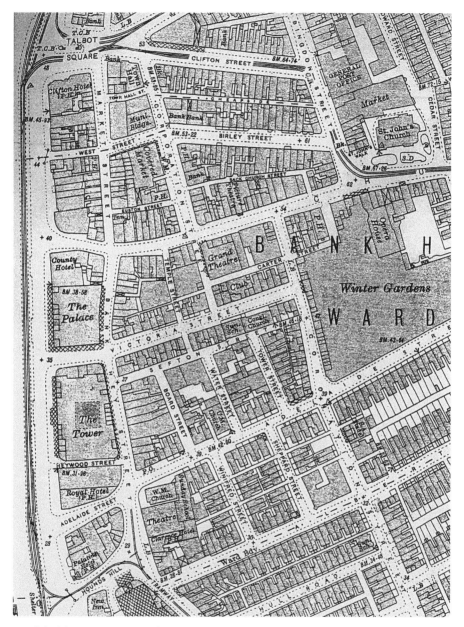

Map of the Town Centre's Lost Streets

The most notable 'lost' streets in the town centre are those of Sefton Street, Tower Street, Water Street, Board Street and parts of Temple Street and Adelaide Street, swallowed up by the Houndshill Shopping Centre. One of the first town centre streets to disappear was Euston Street in 1939, later covered by BHS. Other 'lost' streets include Town Hall Street between the Town Hall and the Municipal Buildings, Winifred Street, Sheppard Street, and Heywood Street between the Tower and the old Woolworths building.

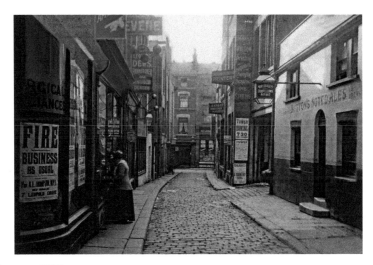

Euston Street, *c*. 1900

In the 1830s, Euston Street was a street of small businesses, stables and warehouses between Lytham Street (Corporation Street) and Market Street. The Market Hotel was at the Lytham Street end and the Castle Inn on the south side at the Market Street end. The Oddfellows Arms was at No. 4 Euston Street. It was all demolished in 1939 and the site used as a car park until the BHS store opened in 1957. BHS closed in 2016. (Courtesy of Blackpool Central Library)

Temple Street from Sefton Street

Temple Street originally ran from Church Street to Victoria Street and was later extended to Sefton Street. Henry Johns & Son (1864) wine and spirit merchants were next to the tobacconist on the Church Street corner and the *Evening Gazette* offices were on the Victoria Street corner. In the 1960s, there was also the Temple Grill, J N Diggle's toy shop with Shaws Surgical Store at the Sefton Street end.

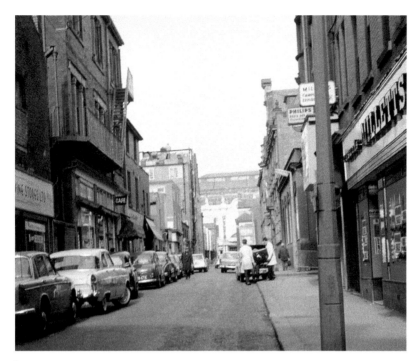

Sefton Street

The name 'Sefton Street' was usually followed by the words 'behind the Tower'. It was originally named Back Victoria Street and was then a back street. The lower end near the Tower was widened and occupied by shops such as Milletts, J. Aireys Wine Stores and the Famous Army Stores. The street and shops were all demolished in the late 1970s to make way for the Houndshill Shopping Centre, which opened in 1980.

Tower Street

Tower Street, originally named South Edward Street, was generally a street of warehouses with the Blackpool Tower Company building on the east side. It was most well known for being the location of Brian London's famous 007 nightclub. The properties on the west side of Tower Street were demolished to make way for the Houndshill Shopping Centre. The properties on the east side survived until recently. The area is now a car park. Construction of a new Wilko store on Coronation Street/Tower Street is planned.

Water Board Offices, Sefton Street

This photograph of the Fylde Water Board's headquarters on Sefton Street, on the corner with Water Street, was taken by the late Alan Stott. The offices opened on 4 October 1906 and were demolished in 1975 to make way for the Houndshill Shopping Centre. (Courtesy of Alan Stott and Melanie Silburn)

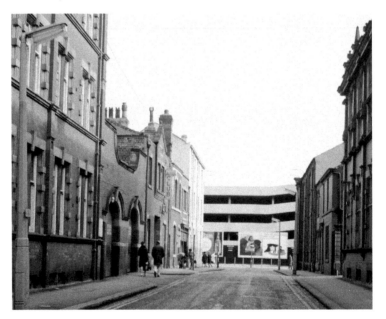

Water Street

Water Street was the middle of the three streets 'behind the Tower', between Sefton Street and Adelaide Street, and was originally named Dixon Street (until 1925). There was a working men's club on the east side.

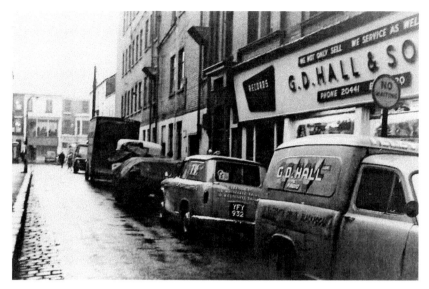

Board Street

Board Street was originally named Hull Street and housed the Council Yard and Blackpool's first fire station from 1878. G. D. Hall & Sons TV, radio and record shop is seen in this early 1960s photograph on the Sefton Street corner.

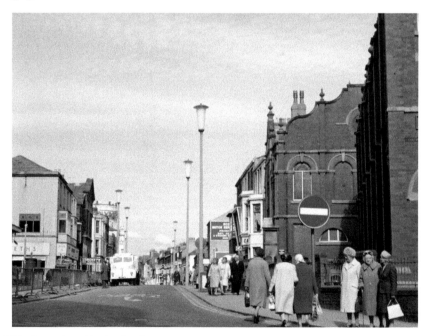

Adelaide Street from Bank Hey Street

This much-changed view, looking east, of Adelaide Street from Bank Hey Street was taken shortly after the RHO Hills fire of 1967. To the left is Heskeths fish and chip shop and to the right is the Wesleyan Methodist Church (1862–1972), now Shoe Zone with Central Methodist Church above. A section of Adelaide Street near Coronation Street has been consumed by the Houndshill Centre.

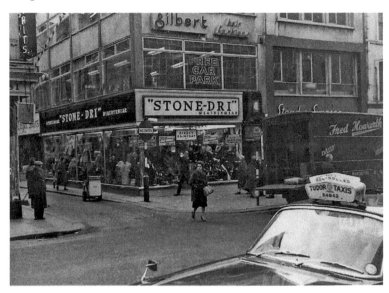

Stone-Dri, Church Street

Stone-Dri was founded when the four Stone brothers took over their father's Salford coat-making business in the 1940s. The business expanded into retail and by 1960 had some eighty-five shops nationwide, including its shop on the corner of Church Street and Temple Street. Next door was the Stead & Simpson shoe shop, then Alexandre menswear. Stone-Dri was taken over by Fosters in 1973 and the brand left to go dormant. The brand has been resurrected by Baker Street Group Brands. The shop is now a Pound Store.

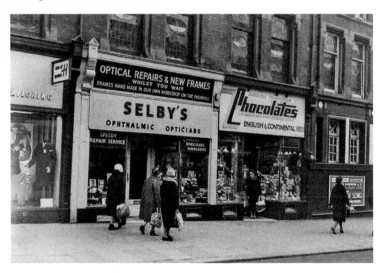

Selby's Opticians

H. J. Selby Limited were opticians established in 1925 and had premises at No. 37a Church Street (seen here) and also No. 42 Clifton Street. The adjacent Grand Theatre chocolate shop and Selby's are now a jewellers. To the left of the picture is Hepworths men's tailors, and next to Hepworths was Henry Dodgson, ladies outfitters.

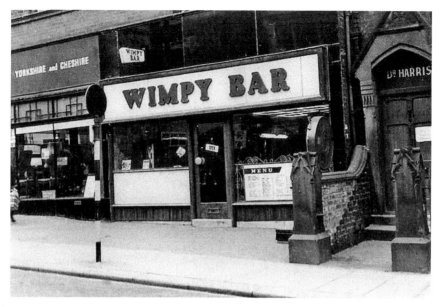

Wimpy Bar, Victoria Street

The first Wimpy Bar was introduced into the UK (in London) in 1954, under a licence to J. Lyons. They specialised in hamburgers and fries. Cutlery was not needed, drinks came in bottles with a straw and condiments were pre-packaged. Wimpy suffered as McDonald's grew (from 1974); today there are some eighty Wimpy restaurants, down from over 500 in the UK in the 1970s. Blackpool's first Wimpy, seen here in 1963, was located near the top of Victoria Street.

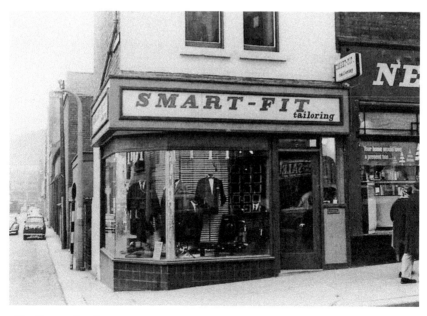

Smart-Fit, Coronation Street

This 1963 photograph shows the Smart-Fit men's tailors shop at No. 21 Coronation Street on the corner of Sefton Street. Next door was New Day furniture shop, which was on the corner of Victoria Street. The block is now occupied by Bella Italia.

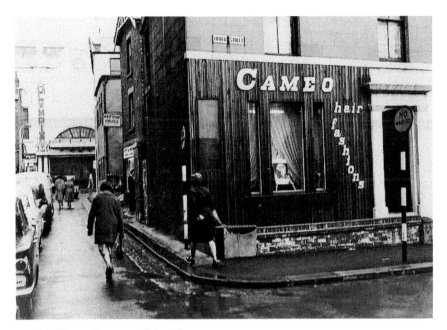

Cameo Hair, Tower Street and Sefton Street

This 1963 photograph of the Cameo Hair salon at No. 13 Tower Street was taken as a part of a survey of properties in the area that was already destined to become Blackpool's first shopping centre. The premises later became a taxi office and benefitted from its proximity to the 007 nightclub on the other side of Tower Street.

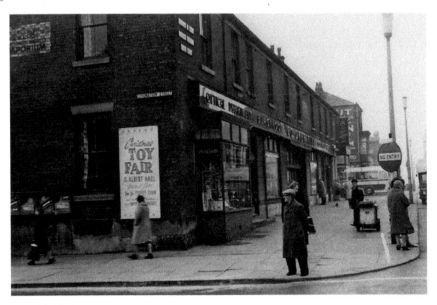

Co-op, Adelaide Street

The property to the left in this photograph was previously boarding houses on Adelaide Street and was extended into by the Co-op Emporium after it opened on Coronation Street in 1938. This property housed an opticians, chemists, and dental surgery above. It is now the site of New Look fashion store on the Adelaide Street corner of the Houndshill Centre.

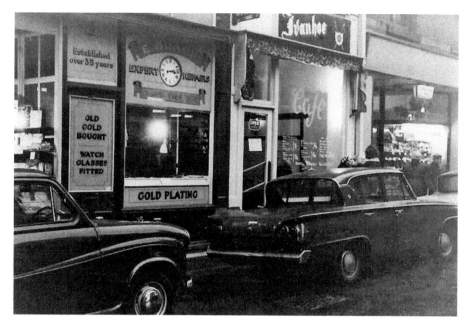

Ivanhoe Café, Sefton Street

The Ivanhoe Café was a well-known and much-loved establishment at No. 5 Sefton Street, between E Black (watch repairs) and K & M Cook (jewellers). The decor in the café was complete with swords, shields, hunting trophies etc. The home-cooked food and cakes were prepared in the basement.

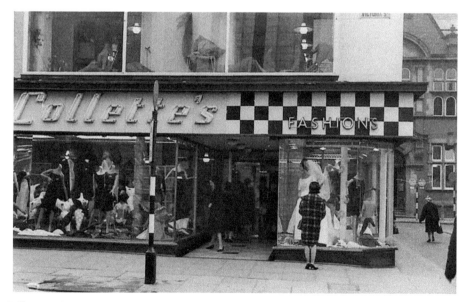

Collette's, Victoria Street

Collette's ladies fashion shop, on the south side corner of Nos 35–39 Victoria Street and Temple Street, is seen here in late 1962. It had a bridal department. Like many other properties on the south side of Victoria Street, it was demolished in the late 1970s to make way for the Houndshill Centre.

4

Central Blackpool

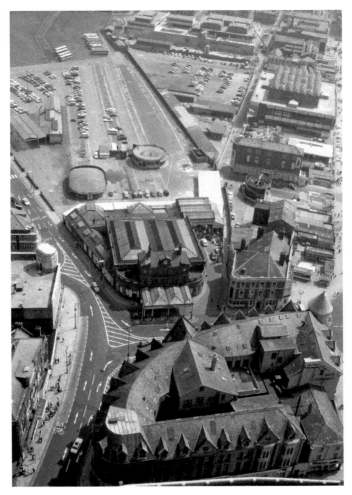

Central Station from the Tower

This late 1960s photograph shows the station building and entrance canopy, and that the track areas between the fourteen platforms of Central station have been filled in and the site is being used as a car/coach park. In the distance the new court buildings are under construction, and Bonny Street Police Station has not yet started to be built. This photograph also shows the New Inn, the Palatine Buildings (demolished in 1973), the Queens Theatre and the start of the modernisation of the Golden Mile. (Courtesy of Kevin Lane)

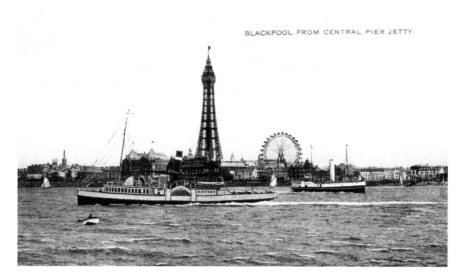

Paddle Steamers

Paddle steamers first started operating from North Pier in 1864, with sailings thereafter to local resorts such as Fleetwood, Morecambe, Southport and the Isle of Man. There was competition from the Bickerstaffe family, who owned Central Pier and who operated steamers from 1870. In this *c.* 1910 postcard, the Lune (1892–1913) is to the left and the Greyhound (1895–1923), said to be the finest of Blackpool's pleasure steamers, is seen to the right. Sailings stopped in 1939.

North Pier Jetty

North Pier was built in 1862–63 and the jetty in 1868, making the pier approximately 500 metres in total length. The jetty was used by paddle steamers between 1868 and 1939. The jetty was also popular for sea fishing. Severe storm damage in 1997 severed the jetty from the main part of the pier and it was subsequently removed. The pier is now 402 metres long. (Courtesy of Ian McLoughlin)

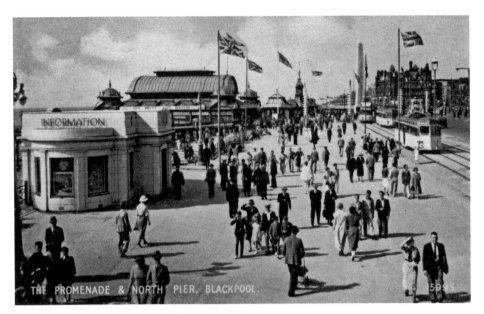

Promenade Tourist Information Office

This 1949 postcard view shows the first faience-clad Tourist Information Centre, built *c.* 1930 on the promenade just south of North Pier. It was replaced in 1989 by a new, octagonal building. Festival House, the new Tourist Information Centre, Registry Office and Beach House bistro bar on the promenade, was completed in late 2011 and opened by HRH Prince Edward on 7 February 2012.

Tower Menagerie

When the Tower was opened in 1894, a menagerie was incorporated into the second floor. The Tower Menagerie kept lions, tigers, polar bears, other small mammals and tropical birds. The menagerie closed in the early 1970s – around the time Blackpool Zoo opened.

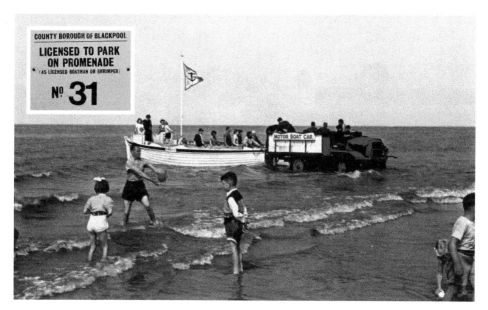

Motor Boats, Central Beach

In the summer days of the post-war years, when simpler pleasures were sufficient, motor boat trips from Central Beach were popular. The boats were clinker built (overlapping hull planks) and the trucks were ex-army. The boat in this 1956 photograph was owned by 'Old' John Stanhope who is standing at its bow, between the splash boards. The boat is still in use, as a fishing boat, in Barrow.

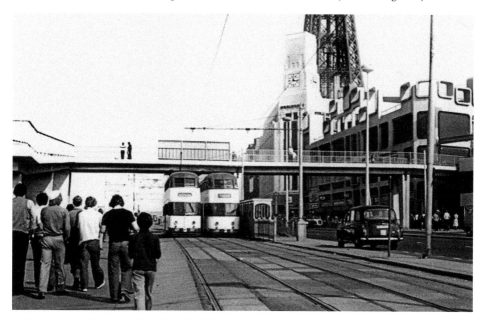

Bridge over the Promenade at Hounds Hill

The concrete footbridge over the promenade adjacent to Coral Island was built *c.* 1976 to connect the Houndshill Shopping Centre to the promenade. It was little used and generally considered to be an eyesore. It was demolished in August 2009. The section over Bank Hey Street was demolished in August 2018. (Courtesy of Dr Neil Clifton)

Hounds Hill

The Houndehill in Laton (from which Hounds Hill derives its name) is one of the oldest parts of what became Blackpool. As shown in the photograph, it was not located where the current Houndshill Shopping Centre stands, but was in the area of what was Central station/New Inn (to the right)/the Palatine Building on the promenade and Feldmans Theatre. The road is now largely pedestrianised and is between the Coral Island building and what will be the Sands Venue Resort Hotel.

Brunswick Street

Brunswick Street was a street off the centre of the Golden Mile, which ran east to the railway lines near Central station. The Victoria Hotel stood on the north (promenade) corner and was later used as Ripley's Odditorium. It was demolished in late 1970s and Funland amusement arcade was built. Brunswick Street exists now in name and in part only. It is the pedestrianised 'alley' at the side of Funland passing between the promenade and Bonny Street.

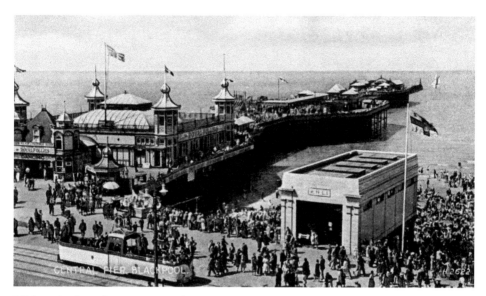

Lifeboat Station adjacent to Central Pier

Blackpool's first RNLI Lifeboat House was on Lytham Road just behind where the Manchester Bar is today. The first lifeboat launch was the *Robert William* on 20 July 1864. In 1937 a new lifeboat station adjacent to Central Pier (seen here) was opened by the Duke of Kent. Blackpool's new lifeboat station and visitor centre on Central Promenade, near to New Bonny Street, was completed in September 1998 and today it has three inshore lifeboats in service.

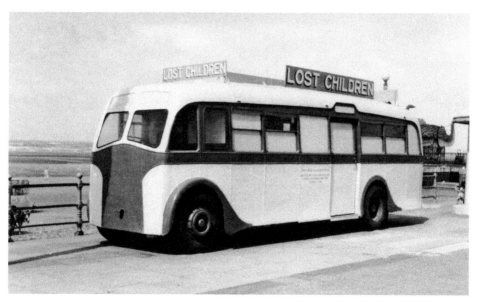

Lost Children Bus

The 'Lost Children' bus on the promenade adjacent to the sea wall at Central Beach was a facility provided by the council in the summer season of the busy post-war years. It was open daily from 10 a.m. to 6 p.m. The bus seen here in this 1962 photograph is a Leyland Tiger T27 single-deck bus in Blackpool Transport's livery colours of cream and green. (Courtesy of Huddersfield Passenger Transport Group)

Oddfellow Street

Oddfellow Street was on Bonny's estate in the packed terraced streets between the Golden Mile and the railway lines into Central station. Our House Inn (a beerhouse between the 1870s and 1900) stood on the corner of Oddfellow Street and Cragg Street. This photograph was taken in September 1963 shortly before the properties in the area were demolished to make way for the magistrates' court and police station buildings. (Courtesy of Alan Stott and Melanie Silburn)

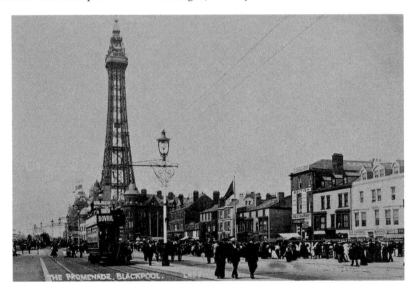

The Golden Mile

In the late 1800s, the promenade property south of Hounds Hill to Chapel Street (South Beach) was largely residential, catering for seasonal visitors. When the council placed restrictions on traders operating on Central Beach in 1897, they moved their stalls on to the frontages of the promenade property opposite. Amusement arcades, sideshows, ice cream and fish and chip stalls gradually took over the properties along this length and the Golden Mile was born. From the 1960s, the old properties were demolished and replaced with modern amusement arcades. (Courtesy of Peter Dumville)

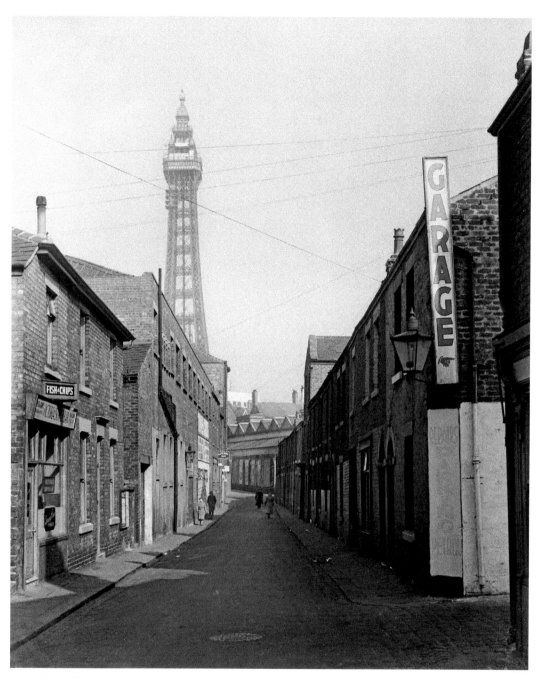

Bonny Street

The Bonny family owned and leased much land in Blackpool and Norman Cunliffe (*Aspects of Blackpool's History*) informs us the name Bonny first appeared in a 1676 census. This followed Richard Carter's bequest in 1663 of his Lower Blackpool land to one of the Bonnys of Layton. South Beach (Golden Mile) developed from 1840s and John Bonny built a house named Rockcliffe and the Victoria Hotel. Bonny Street, behind South Beach, was opened up in the 1840s. It is seen here in this 1955 photograph by Arthur Hallas. The properties of the Bonny estate were demolished in the 1960s.

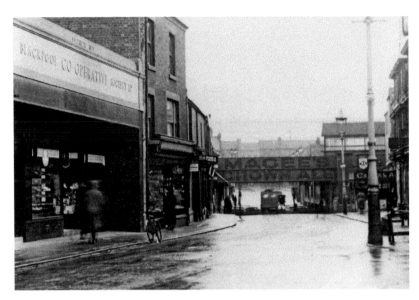

Chapel Street

Chapel Street is one of Blackpool's oldest roads leading to the sea. Bonny's Farm, at the east end, near Central Drive, was one of Blackpool's earliest lodging houses and was demolished in 1902. The properties to the left were demolished in the late 1960s to make way for the new magistrates' court buildings, car park and road widening. The steel-decked bridge was built *c.* 1863 to carry trains into Central station and replaced in 1985 by a concrete bridge with novel earth-reinforced abutments.

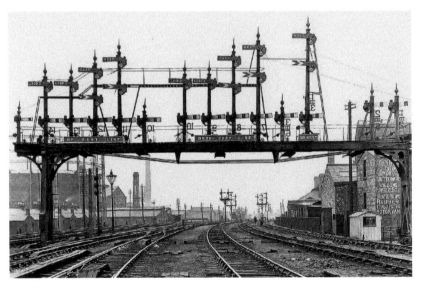

Central Railway Lines

This 'industrial' view of the railway lines and surrounding area *c.* 1950 is just south of Chapel Street and only yards from the promenade. Following the lines opening in 1863, Central station was to become one of the busiest railway stations in the country, but was closed in 1964. The land was used as a coach park and in the 1980s the road from the M55 and Yeadon Way to the town centre was constructed along the old railway route.

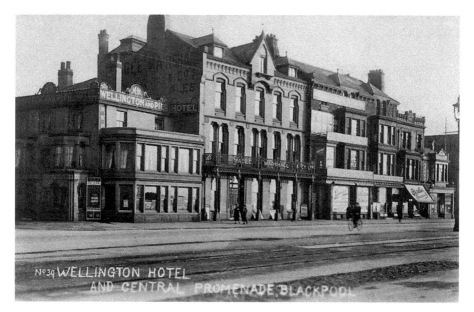

The Wellington and Pier Hotel, Promenade at Chapel Street

Originally built in 1851 by Robert Bickerstaffe as a forty-bedroomed family hotel. It was situated in the enviable position directly opposite what is now Central Pier. It was rebuilt *c.* 1953 in a vague art deco style and was later the Tavern in the Town. In the 2000s it was, in part, McDonald's and is now occupied by holiday souvenir shops at promenade level. (Courtesy of Peter Dumville)

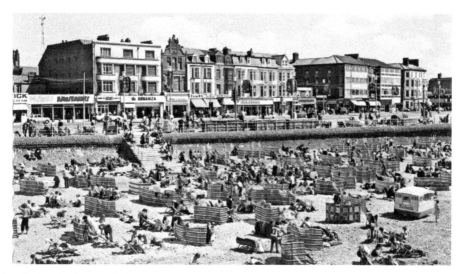

Beach, South of Central Pier

Hiring a striped canvas deckchair (and possibly a windbreak) was not particularly a tradition but a natural way to have a pleasant afternoon on the beach with the children. Banks of council-owned deckchairs were located along the seafront, usually manned by students in the summer season. The pastime of spending the afternoon on the beach declined through the 1980s and '90s and the council stopped hiring them *c.* 2010. It sold the remaining stored deckchairs in 2014.

Ibbison Street, Revoe

In 1863, Thomas Ibbison bought 3 acres of Revoe Farm from John Moor and built houses on the line of the future Central Drive. A beerhouse named the Revoe Inn was at the corner of Ibbison Street and Central Drive was demolished around 1893 for the building of the George Hotel. Ibbison Street was demolished by the council in 1974 and replaced by the sheltered housing and community centre of Ibbison Court. (Courtesy of Alan Stott and Melanie Silburn)

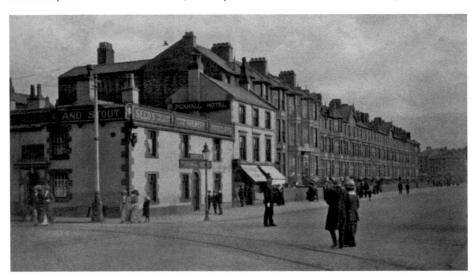

The Foxhall

Around 1660, Edward Tyldesley built Fox Hall. The house fell into disrepair and was later used as a farmhouse, then as a beer shop, lodging house and inn. It suffered a fire in 1955, but parts of the original hall survived in the fabric of the replacement building. It was sold to C&S in February 1964 and was demolished in December 1990. The current red-brick building now houses Reflex, a 1980s-themed bar and nightclub, which opened in 1991.

5

South Blackpool

The Star Hotel

The Seven Stars was built *c.* 1850 on sand dunes at South Shore, just above the high-water line, and was known as the Star Inn by 1885. In May 1932, the new Star Hotel opened, fronting the new promenade. It was purchased by the Pleasure Beach in 1994 and changed its name to the Apple and Parrot in 2014. In 2016 it reopened as The Star but was demolished in early 2018. A new hotel is being built on the site.

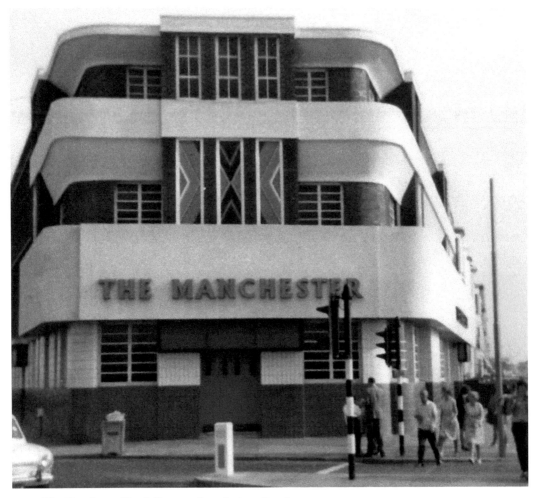

The Manchester Hotel, Promenade at Lytham Road

The original building dates from 1845 when it was known as Manchester House. In the 1860s and '70s it was named Hemingway's Manchester Hotel. The Manchester Hotel (as seen here) was rebuilt and opened in May 1936 by C&S in an art deco style. It was altered in the 1960s and rebuilt in the current red-brick style in 1996. The pub is now named The Manchester Bar and is owned by Stonegate. (Courtesy of Ian McLoughlin)

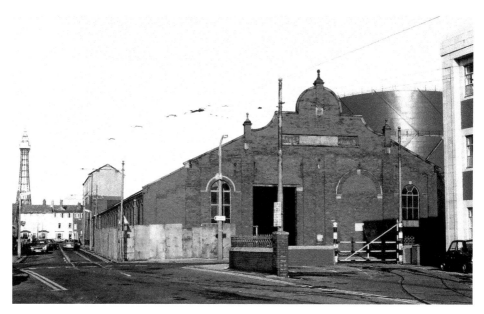

Blundell Street Depot

The town's first tram depot opened in 1865 on Blundell Street to serve the conduit car fleet. It was extended over the years to store forty-five trams on five tracks. It became a store in 1935 when the new Rigby Road depot opened. From 1956, the building was used as a bus garage. Later, the roof became unsafe and the depot was demolished in November 1982. The site became a council car park and is now part of a major housing regeneration scheme in the Foxhall area. (Courtesy of the Spencer Collection)

Blackpool Borough Rugby League Club, Princess Street

Blackpool Borough Rugby League Club was accepted into the Rugby League in 1954 and originally played at the Greyhound Stadium on St Anne's Road until 1962. Blackpool Borough played at Borough Park, Princess Street, from 31 August 1963 until 4 January 1987, beating Salford 36-16 in their first match there. The team wore tangerine, black and white jerseys. An Odeon cinema and other facilities replaced the rugby ground in 1998. (Courtesy of the Ray Maule Collection)

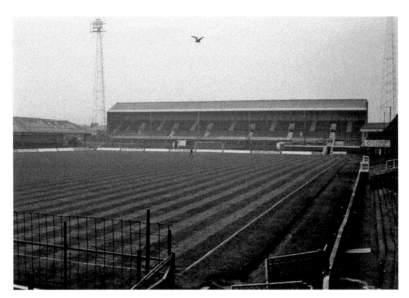

Blackpool Football Club, December 1982

The club was founded in 1887, moving to Bloomfield Road in 1901. Its heyday was in the 1950s. Blackpool lost the FA Cup finals of 1948 and 1951, but won the 1953 Matthews FA Cup final against Bolton Wanderers. They finished runners-up in the First Division in the 1955/56 season. They were promoted to the Premier League in 2010 but relegated in 2011. They are now in English Football League 1. One of their greatest players was England captain Jimmy Armfield (21 September 1935 to 22 January 2018). (Courtesy of the Ray Maule Collection)

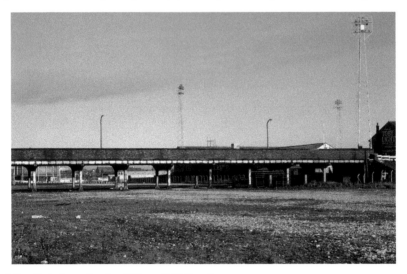

Central Car Park Area, South of Bloomfield Road

Following the opening of the Blackpool and Lytham Railway to Central station, the land north of Waterloo Road became railway sidings. Following the closure of Central station and the line to South Shore in 1964, the area seen in this 1975 photograph became a wasteland. Yeadon Way opened in January 1986 and, at the same time, the council completed and linked its road, now named Seasiders Way (originally named Spine Road), into the town centre. Bloomfield Road bridge was demolished *c.* 2014. (Courtesy of Ian McLoughlin)

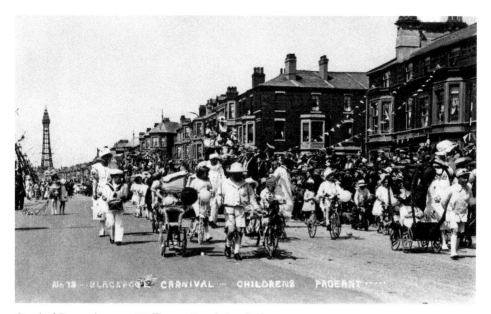

Carnival Procession near Wellington Road, South Shore

The Blackpool carnivals held on 9–16 June 1923 and 11–24 June 1924 were a huge success, with processions between Gynn Square and the Pleasure Beach attracting over 100,000 visitors. Craftsmen from Nice were engaged to make papier mâché heads and figures. Local businesses decorated floats and local children and others joined the procession in fancy dress. The carnival was revived as an annual event in July 2017, with a parade from Central to South Pier.

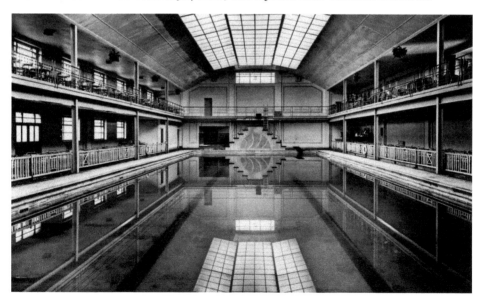

Lido Swimming Pool

The 25-metre, six-lane Lido Swimming Pool on Lytham Road was built in 1934. Thousands of Blackpool children learned to swim there. It did not have any diving boards. It had a small (12-metre) learner pool and a health and fitness studio. It closed on 1 July 2005 and the building was demolished in 2006. The New Blackpool Enterprise Centre opened on the site in 2007.

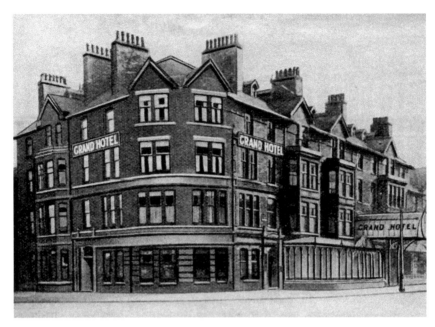

Grand Hotel, Station Road

The Grand Hotel was built in the 1890s and had sixty bedrooms. In its time, it was owned by Magee Marshall and C&S in the early 1950s when it was converted into a public house and later still Bass Lancashire, who refurbished it, retaining the large original mahogany bar. The upper floors were converted into self-catering apartments but closed in 2008. The property burnt down on 28 July 2009 and was subsequently demolished. The site remains undeveloped.

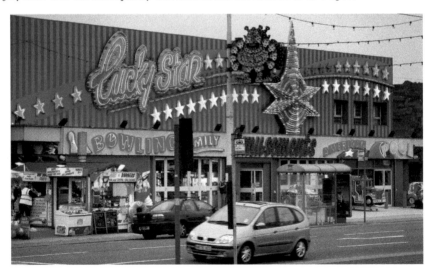

Lucky Star Amusement Arcade, South Promenade

The Lucky Star amusement arcade, with its colourfully lit exterior, was on South Promenade adjacent to Withnell Road. It was used as the backdrop in the 2004 BBC comedy musical *Blackpool* starring David Morrissey and David Tennant. It was demolished to make way for Wetherspoon's new Velvet Coaster pub, which opened in May 2015. (Courtesy of Richard Morrison)

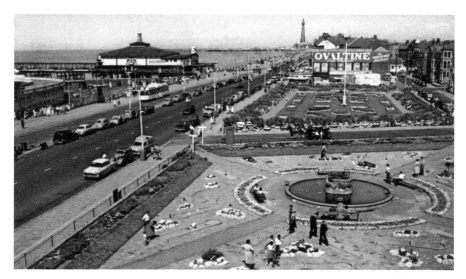

Gardens, South Promenade

The gardens to the west of Simpson Street between Withnell Road and Balmoral Road were originally beach before the sea wall was extended to Balmoral Road *c.* 1900. The landscaped garden area to the north is known as Flagstaff Gardens, but is now partly paved with an open grassed area. The fountain seen in this 1950s postcard view of the crazy golf course was removed in 2007 and the Adventure Golf attraction was built.

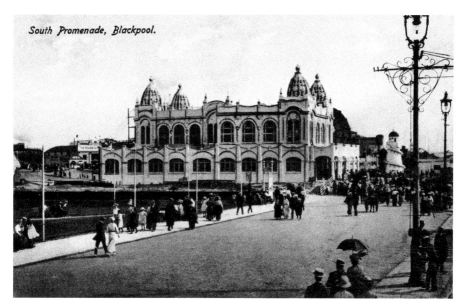

Pleasure Beach Casino

The Pleasure Beach developed from the unorganised fairground that sprung up in the 1880s to 1890s south of Balmoral Road. In 1903, William Bean and John Outhwaite purchased the Watson estate lands, and their first major attraction was Sir Hiram Maxim's Captive Flying Machine in 1904. The first casino, seen in this photograph, was built in 1913 and contained a restaurant, picture theatre and billiard room, but not gaming. It was demolished in 1937 and a modernist-style casino opened in May 1938.

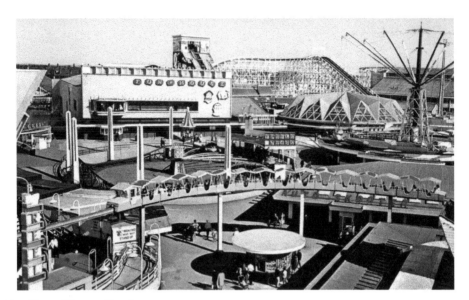

Fun House, Pleasure Beach

The Fun House at the Pleasure Beach was designed by architect Joseph Emberton and built in 1934. It was a 'must-do' attraction, with its moving staircase, steep four-lane slide, mixing bowl and rotating barrel. It had the famous 'Laughing Clown' located immediately outside from 1935. The Fun House was destroyed by a fire in 1991 and the site now houses the indoor, dark, water Valhalla ride, which opened in 2000.

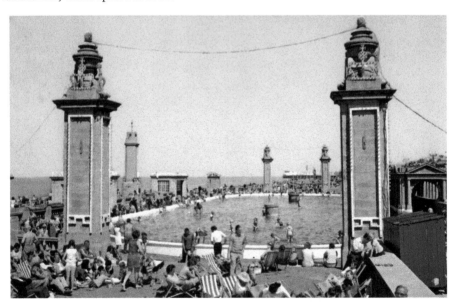

Harrowside Paddling Pool

In 1922–26 the council built the sea wall from near South Pier to Starr Gate. The new sea wall was some 400 feet westward of the old foreshore. The widening works incorporated a series of sunken gardens. At Harrowside, a raised model yachting pond was formed with a pair of pillars at each end and with classical shelters and a colonnade. In this early 1970s postcard view seen here, the children's paddling pool was popular on hot days.

Arnold Boys' School, Lytham Road

Arnold School was an independent school founded on 4 May 1896 and was named after Dr Thomas Arnold, headmaster of Rugby School. In 2013, the school merged with King Edward VII & Queen Mary School and now is named AKS School, based in Lytham St Annes. The Armfield Academy, named after Jimmy Armfield, the legendary Blackpool FC and England captain is now on the Lytham Road, Blackpool site. The new school opened on 10 September 2018.

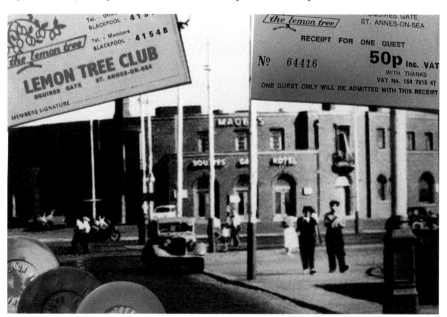

Lemon Tree Hotel, Squires Gate Lane

The Squires Gate Hotel was built in 1939. From the 1960s, the building was the excellent Lemon Tree nightclub and casino with the Mexican Bar downstairs. It was owned by the Levine family. The nightclub comprised the Club Room, where Erskine was the head barman for several years, the Pagoda Room with its tropical ambience and revolving stage, and disco upstairs. The hotel was demolished *c.* 1993 and sixty-three retirement/sheltered apartments built in 1994, sympathetically named Lemon Tree Court.

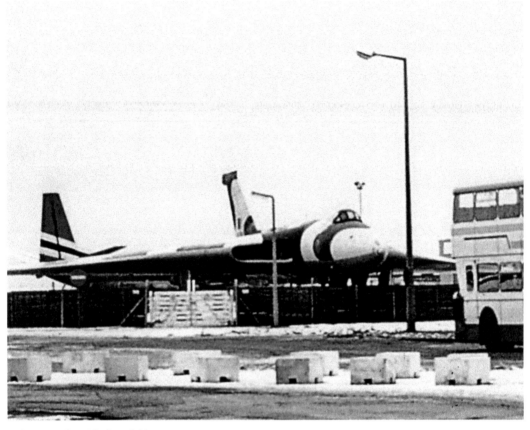

Vulcan Bomber, Blackpool Airport

The delta-winged Avro Vulcan Bomber (XL391) was purchased by Mr Bateson from the RAF as scrap and flown to Blackpool Airport in February 1983. It stood at the airport entrance until it was scrapped in 2013. It was a sad end for XL391, which had played its part as a nuclear deterrent in the Cold War and on standby in the Ascension Islands during the Falklands War. The airport is now a base for the North West Air Ambulance, flying schools and helicopter flights.

6

Around Blackpool

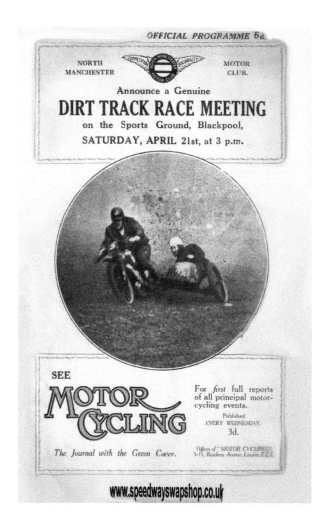

Speedway

Blackpool had two dirt track racing venues in the late 1920s. There were meetings at the half-mile Highfield Road Sports Ground track between April 1928 and 1930, with over 7,000 spectators at the first meeting. The land was sold in April 1931 and Highfield School built. Meetings at the St Anne's Road Stadium track, between 11 September 1928 and 1929 were inside the greyhound track. The land was sold for housing *c.* 1964 and Stadium Avenue now occupies part of the site. (Courtesy of Derek Carruthers)

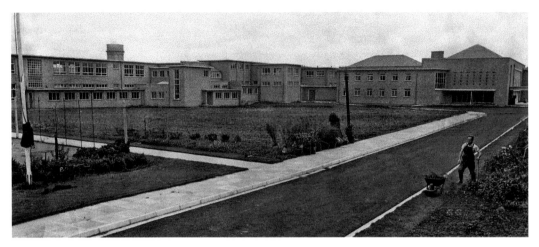

Arnold High School for Girls, Greenlands, Bispham Road

The school had its origins in Northlands School on Springfield Road, run by Miss Smallpage. It later moved to Lytham Road opposite the old Lido Baths, becoming Arnold High School for Girls in 1929. In 1949, Blackpool Council took over the school and a new school at Bispham Road opened in 1954. Claremont Girls Secondary Modern merged with Arnold in 1975 to become Greenlands High School, before becoming Bispham High School. This school later merged with Collegiate High School. It was demolished in 2017. (Courtesy of *Evening Gazette*)

Blackpool Grammar School, Collegiate

The foundation stone for the first Boys' Grammar School at Raikes Parade was laid on 1 October 1904. Blackpool Grammar School moved to Highfurlong in 1961. Collegiate Girls' School merged with the grammar school in 1971 and the nearby sixth-form college opened in 1972. The site of the grammar school is now the Aspire Academy, formed following the merger of Collegiate High School and Bispham High School Arts College in 2014. (Courtesy of *Evening Gazette*)

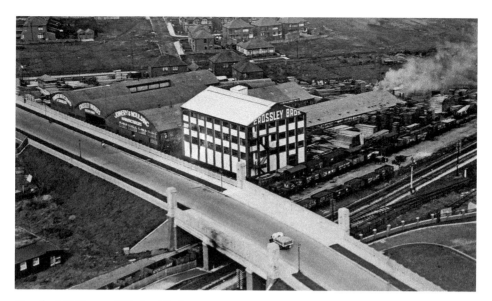

Crossley's Bridge and Timber Works

This is known locally as 'Crossley's Bridge' due to Crossley Brothers timber works on Holyoake Avenue. Harry and George Crossley moved to Blackpool from West Yorkshire with their families in 1920 and purchased a site adjacent to Bispham station. Crossley Brothers was sold in 1979 to a national timber company. B&Q was built in 1983 but closed in 2015. It is now Poundstretcher. The adjacent Comet store (1986–2012) is now a Pets at Home. Plymouth Road bridge was opened in June 1932 and has recently been rebuilt, reopening on 7 April 2017. (Courtesy of Peter Crossley)

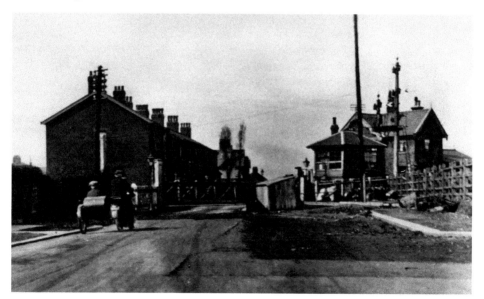

Bispham Station Level Crossing, Bispham Road

Before Crossley's Bridge, which opened in 1932, there was a level crossing on Bispham Road at Layton railway station, then known as Bispham station, despite being within Little Carleton's boundary.

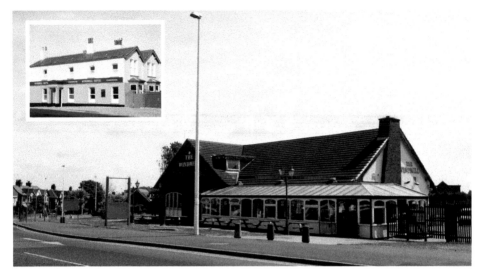

Windmill Pub, Westcliffe Drive, Hoo Hill

Hoo Hill House, with stables, a bowling green and gardens, was built on this site *c.* 1836 by Robert Bonny, who obtained a drinks licence and later named it the Mill Inn. It was bought by C&S in 1924 and by 1930 was named the Windmill Hotel. It was demolished in 1979 and a new Mitchells and Butlers public house was built with a sun lounge. The pub closed in June 2010 and a Tesco Express opened in October 2010. (Courtesy of Barry Sidley)

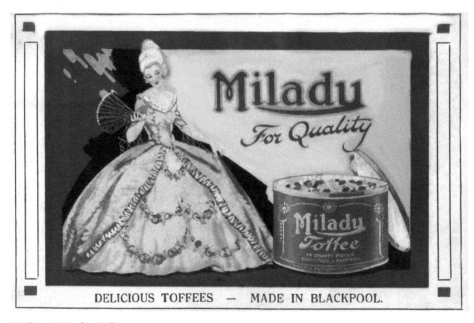

Waller & Hartley Ltd

Blackpool has had several sweet factories over the years, the most famous being Waller and Hartley's factory on Coleridge Road, built in the late 1920s. It employed over 700 people at one time, producing Milady Toffee and Rum & Butter Toffees, sold in colourful tins, which are now collectors' items. In 1972, Waller & Hartley Limited was acquired by Barker & Dobson. The premises closed in the mid-1970s and was demolished. The factory site is now sheltered housing.

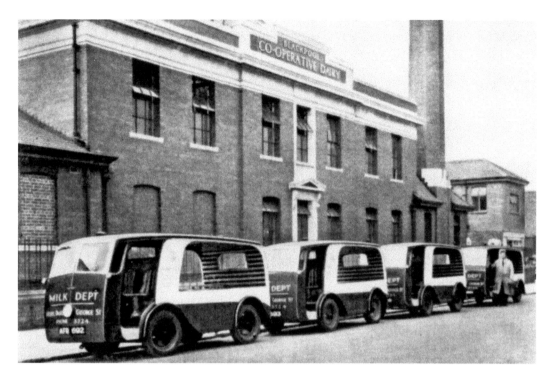

Co-op Dairy

The Blackpool Co-operative Dairy buildings (with chimney) on George Street at the corner with Coleridge Road were built *c.* 1930. They were used for the bottling and distribution of milk for some seventy years. The buildings were used by the Blackpool Brewing Co. Ltd as a brewery from November 2000 to 2003. It was demolished *c.* 2013 and the land is currently undeveloped. (Courtesy of Peter Williams)

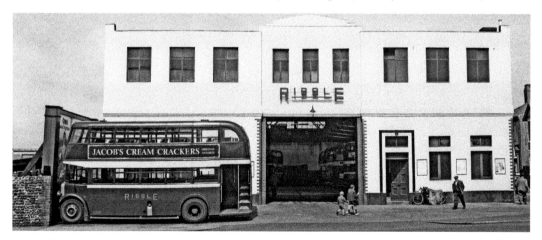

Ribble Bus Depot

This view of the Ribble Motor Services depot at Nos 95–97 Talbot Road, adjacent to Cecil Street, was taken on 14 August 1956. The red-liveried Ribble bus is a Leyland PD2 2744. Ribble became part of Stagecoach on privatisation in 1988 and the depot was later used by Abbott's Coaches but closed in the late 1990s. The depot was bought by Savoy Timber *c.* 2002. There was also a Ribble bus depot at No. 127 Devonshire Road (now Lidl's car park) which was demolished in 1988. (Courtesy of Kevin Lane)

Flying Handbag, No. 172 Talbot Road

Built *c*. 1860, the King's Arms was on New Road (Talbot Road) and was owned by Higsons Brewery Ltd (Liverpool). Fylde CAMRA held their first branch meeting there in 1980. Boddingtons took over Higsons in 1985 and the pub became Sam's Bar in 1990. It was later transformed into an alehouse and then the Flying Handbag. The Handbag was demolished in 2007 as part of the Talbot Gateway regeneration plan and the site is covered by the new Sainsbury's store. (Courtesy of Ted Lightbown)

Blackpool Indoor Bowling Hall, Lark Hill Street

The indoor bowling hall was owned by the council and was bounded by Lark Hill Street, Talbot Road, George Street and Swainson Street. It was completed in 1987 and had eight flat green bowling rinks and a licenced café. The club closed in April 2009 and was demolished to make way for the Talbot Gateway development. The site is now occupied by the Sainsbury's store. (Courtesy of Phil Heywood)

Lark Hill Street Area

The terraced streets of the Lark Hill area (Seed Street, Lark Hill Street, Swainson Street) were built between the 1860s and 1890s, off New Road (Talbot Road). In 1935, part of an Avro aircraft crashed in Swainson Street and, in September 1940, bombs fell on the Lark Hill area, killing eight people and injuring fourteen others. The property was compulsory purchased by the council with the intention to replace Cocker Street Baths, but remained a rough car park for many years. It is now the site of the Sainsbury's store and the new council offices.

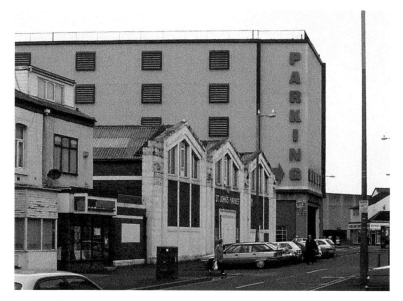

St John's Market, Deansgate

The market at the back of the bus station on Deansgate was built in 1938 and took the St John's Market name in 1939. At its height, it had sixty-three stalls and a café, but closed *c.* 2000 and was demolished in 2002. It is seen here in this 2002 photograph taken from King Street. It is now an open-air car park. (Courtesy of Ted Lightbown)

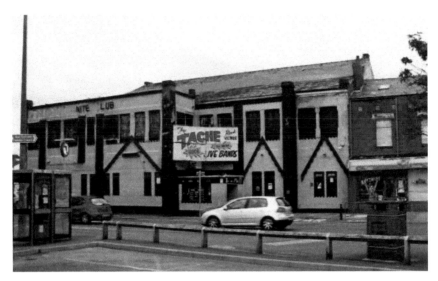

The Tache, Cookson Street

A single-storey building was on this site in 1910 and, at various times, was occupied by F. Waterhouse & Son Auctioneers, Exchange Garage, Peter Quinn's billiards hall, Fleetwood Coachbuilders Ltd and, in the 1970s, a bingo hall. The Tache was a night club, famous from *c.* 1980 as a venue for live rock music. It closed in 2011 and was demolished for the Talbot Gateway development. The Tache Rock Club relocated to the Beat Nightclub above the Rose and Crown pub and continues to promote live music.

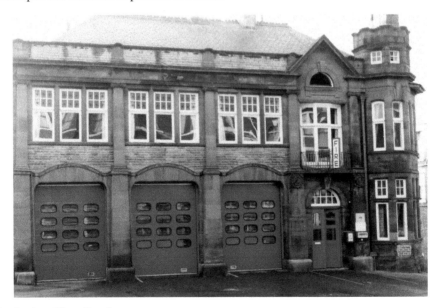

Fire Station, Albert Road

The Blackpool Volunteer Fire Brigade was formed in 1858 and was located in Hull Street (later Water Street). The foundation stone for the Albert Road fire station (near South King Street) was laid in 1900 and the brigade moved there in 1901. It received its first motorised engine in 1913. The Albert Road fire station closed in 1987 and the new central Blackpool fire station at Forest Gate (near Stanley Park) opened 10 April 1987. (Courtesy of the Mark Hopton Collection)

Mickey's Market, Raikes Parade

The former Raikes Smithy on (Raikes Hill) Church Street opposite Park Road suffered a fire in 1988 and was demolished in 1989. It was at that time reputedly the oldest surviving building in Blackpool. It is seen here in 1969. (Courtesy of Alan Stott and Melanie Silburn)

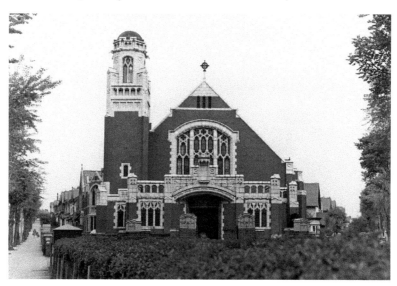

Forest Gate Baptist Church

The church was founded on the site in 1909 and opened in 1910, when Forest Gate was named Hornby Road East. In 1927 the church was extended and was named Whitegate Drive Baptist Church. However, due to poor ground conditions, the building became insecure and dangerous and the church was demolished in 2007. The new Forest Gate Baptist Church was completed by Christmas 2003 and officially opened in 2004 on Forest Gate. (Courtesy of Phil Bolton, Jol Martyn-Clark)

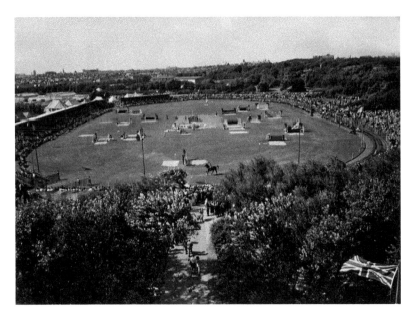

Royal Lancashire Show, Stanley Park Oval

This photograph shows the Athletics Ground in 1949 being used for horse jumping, as part of the Royal Lancashire Show. This agricultural show first started in 1847 and was held at Stanley Park and on the land to the east of East Park Drive, from the 1940s until the early 1970s. The track at Stanley Park was opened in 1961 by Herb Elliot and the International Sports Complex was officially opened by Peter Elliot on 2 May 1988. (Courtesy of *Evening Gazette*)

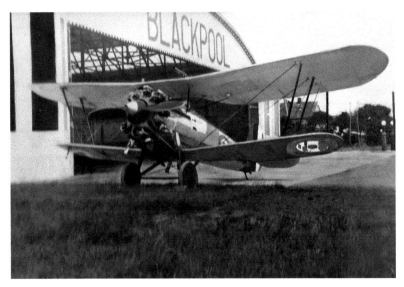

Stanley Park Aerodrome

The land off East Park Drive was farmland until it became Stanley Park Aerodrome in 1929 and officially opened in 1931. The aerodrome was requisitioned as an RAF technical training centre during the Second World War. The aerodrome closed in the early 1950s. Three original hangars and the control tower remain and are used by the zoo. It became home for the Royal Lancashire Show until 1970 and later Blackpool Zoo, which opened on Thursday 6 July 1972.

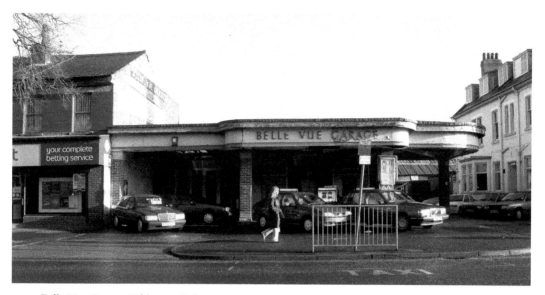

Belle Vue Garage, Whitegate Drive

The original Belle Vue Hotel (1860s) on Whitegate Lane (Drive) was demolished in 1913 and the Belle Vue pub we have today was built in its gardens. The Belle Vue Garage, seen in this 2006 photograph, was built in a modernist art deco style on the site of the old hotel. It was demolished in 2009 and is now the site of a Sainsbury's Local. (Courtesy of Ted Lightbown)

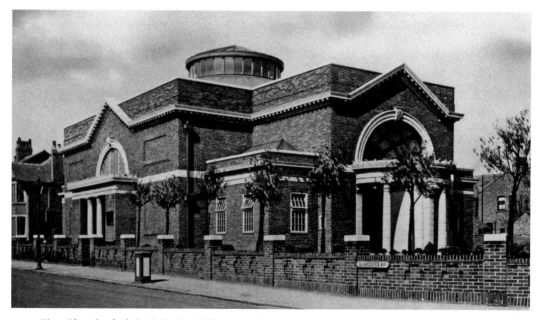

First Church of Christ Scientist, Whitegate Drive

The First Church of Christ Scientist was erected on the corner of Whitegate Drive and Gloucester Avenue in 1928, designed by local architect Halstead Best in a classical style. A dwindling congregation led to the church being demolished and the site redeveloped as the Gloucester Court flats in 1987, with the adjacent Sunday school hall becoming the church. The church was redeveloped into a private dwelling in 2014.

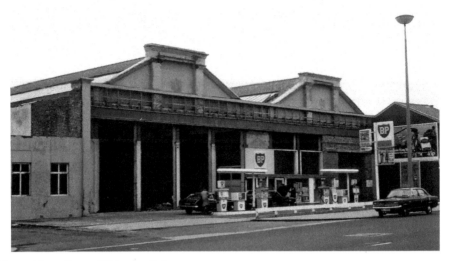

Marton Tram Depot, Whitegate Drive

The depot housed the trams of the Marton route ('the Circular Tour'), which commenced in 1901 and ran from Talbot Square, along Church Street, Whitegate Drive, Waterloo Road and Lytham Road. During the Second World War, the depot was used to make aircraft parts. The route closed in 1962 and the site was occupied by Thomas Motors. The frontage became a petrol station and later the front half was demolished. The site is now a Tesco Express and petrol station with Smiths Equipment Hire occupying the depot buildings behind. (Courtesy of the Spencer Collection)

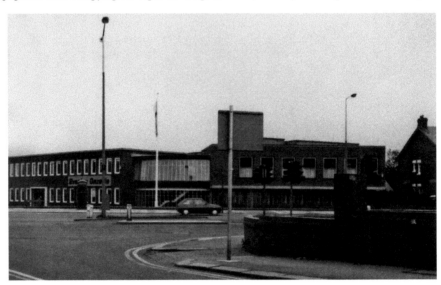

Gazette **Offices, Cherry Tree Road North**

Originally the site of New House Farm, before Preston New Road was completed *c.* 1920. Telefusion House was built *c.* 1960s on the site of the farm on the north-west corner of Cherry Tree Road North. Telefusion operated TV relay services and had retail/rental shops. The *Blackpool Gazette & Herald* occupied the two-storey building between the late 1980s and the late 1990s, after which the building was demolished and two restaurants and a retail unit built in 2001.

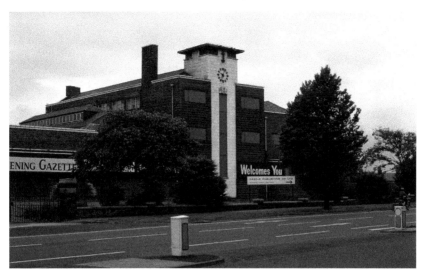

Co-op Bakery, Preston New Road

The Blackpool Co-operative Society Bakery on Preston New Road was built in 1935. The art deco-style building, seen here in 1979, was acquired by the *Gazette* in the 1960s and used by Empire Pools and the *Gazette*. The land was sold for housing (Dove Tree Court) and a drive-through McDonald's restaurant was built on the north east corner of Cherry Tree Road North during the early 1990s. (Courtesy of Ted Lightbown)

Pelham Mount, Park Road

Pelham Mount was a house surrounded by fields in the 1890s and accessed by a track from Great Marton Road (Central Dive). As Blackpool developed, the farmland of the Revoe area was sold for housing. By the 1930s, Park Road was fully constructed and the area transformed. Pelham Mount later became a social club and was last used as a crèche/day nursery. It was demolished in 1998 and the site is now the car park of the Blackpool & The Fylde College University Centre. (Courtesy of *Evening Gazette*)

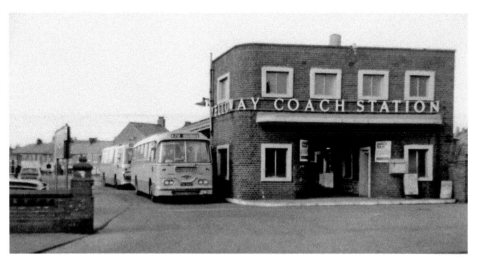

Yelloway Coach Station, Bloomfield Road

Originally the site of Bloomfield, Dr Cocker's bungalow, after which Bloomfield Road takes its name. Yelloway Motor Services developed from a 1902 Rochdale parcel service company. Their name came from the colour of their first (1913) charabanc. The company was sold in 1985 and now operates from Oldham. The coach station, seen here *c.* 1985, had a ticket office, buffet, toilets and a left luggage outbuilding. Magnet joinery kitchen showroom opened on the site in 1986, which became a Lidl store in 1995. Lidl rebuilt the store in 2006. (Courtesy of Brian Botley)

Duple Coaches, Vicarage Lane

In 1960, Duple took over H. V. Burlingham, who built Blackpool's iconic centre-entrance double-decker buses and the famous 'Seagull' coach. Burlingham's main factory was on Vicarage Lane, Marton, from 1931. The coach building industry suffered a downturn in the 1970s. Duple was sold to the Hestair group in 1983, but the factory closed in 1990. The coaches in this photograph are both Duple 'Caribbean' coaches, built on a Volvo B10M Chassis, probably built for dealer stock. (Courtesy of Steve Guess)

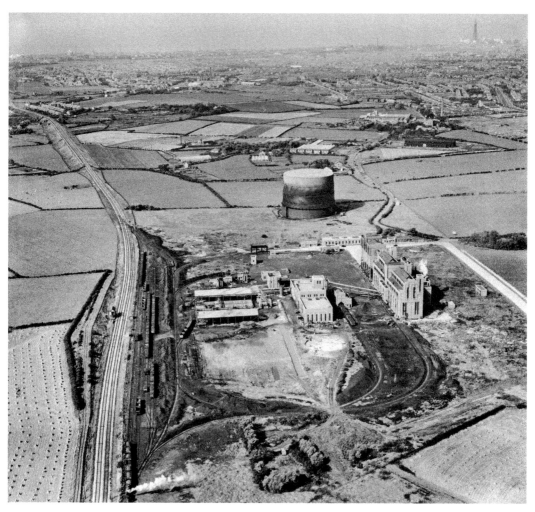

Marton Gasworks

The first gasworks in Blackpool were established in 1851 and were located in Dale Street and later in Princess Street. The Marton Gasworks, seen in this photograph, were built adjacent to the railway on the site of Arnott's Farm on Clayton Road. It opened in 1940 and was bombed in the Second World War. The site is now occupied by the Tesco Extra and the new police headquarters on Clifton Road. (Courtesy of *Evening Gazette*)

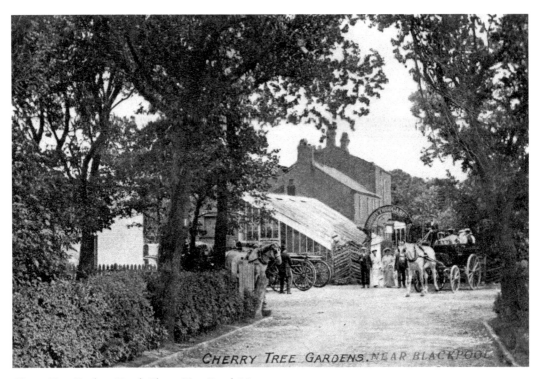

CHERRY TREE GARDENS. NEAR BLACKPOOL

Cherry Tree Gardens Hotel, Cherry Tree Road, Marton

Cherry Tree Gardens Hotel was developed *c.* 1851 from the Cherry Tree Farm and Nursery. In the 1880s its gardens, licenced bars with singing and dancing, and bowling greens were a popular excursion by horse wagonette from Blackpool. It became Your Father's Mustache in 1968 with banjo/oompah jazz band entertainment and closed in 1971. It was purchased by the council in 1972 and became Cherry Tree House retirement home, which was demolished in July 2008. The Tulloch Court apartments were completed in October 2010.

Sources and Acknowledgements

Ted Lightbown, Tony Sharkey, Ian McLoughlin, *Blackpool Gazette*, Emma Harris, Blackpool Local History Library, Caroline Hall, Historic England, Melanie Silburn and the late Alan Stott, Arthur Hallas, Barry Sidley, Ray Maule, Peter Williams, Nick Moore, Peter Dumville, David Slattery-Christy, Dick Craven, Peter Tyler, Kevin Lane, Dr Neil Clifton, Huddersfield Passenger Transport Group, A. Spencer, David Ayres, Richard Morrison, Mark Hopton Collection, Phil Bolton, Jol Martyn-Clark, Matt Jackson and Jim Henry, Derek Carruthers-Speedway Swap Shop, P. Crossley, Phil Heywood, Brian Botley, John Mleczek, Keith Roberts, Norma Fowden, Rebecca Bottomley, Rachel Bottomley, Linda Edgar, Dave Heaney, Ann Lightbown, Michelle Wood, Maureen Wood, Alexandra Winter, Chris Wood, Antony Hill, Clare Wood, Mik McLeod, Shirley Pendleton, Peni Hargreaves, Peter Brooks, Deanna Wood, Andy Gent, John J. Taylor, Mark Preddy, John McWilliams, Arthur Lloyd, Tramtalk, Fylde Coaster, Colin Reed and Gerry Wolstenholme.

About the Authors

This is Chris and Allan's third book together (see *Blackpool Pubs* and *A-Z of Blackpool*). The royalties from this book will be donated to Brian House Children's Hospice, Bispham.

Also available from Amberley Publishing

A fully illustrated A–Z look at Blackpool's most interesting places,
people and events throughout its fascinating past.

978 1 4456 6862 8
Available to order direct 01453 847 800
www.amberley-books.com